Kingston

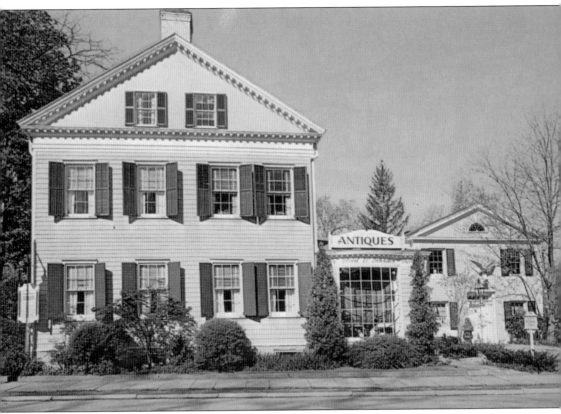

The c. 1812 Fred J. Johnston House was bequeathed to the Friends of Historic Kingston by Fred J. Johnston, a noted antiques dealer and ardent preservationist, when he died in 1993. The landmark house, on the corner of Wall and Main Streets in Kingston's Stockade National Historic District, is in the New York State and National Registers of Historic Places. Founded in 1965, Friends of Historic Kingston works to preserve sites and structures of historical and architectural significance. (Courtesy Friends of Historic Kingston Archives.)

ON THE FRONT COVER: Kingston Point Park on the Hudson River was a major tourist destination from the day it opened in 1897. Visitors came by steamboat, train, and trolley to enjoy the park's many amusements, which included a merry-go-round, dance hall, penny arcade, bandstand, beach, lagoon for row boating, and a new invention called the Ferris wheel. The amusement park closed in 1931. (Courtesy Friends of Historic Kingston Archives.)

ON THE BACK COVER: The train station was built by the West Shore Railroad in 1888 in midtown Kingston, spurring the area's commercial growth. In addition to hotels and restaurants, many factories were built in the neighborhood to take advantage of the nearby shipping facilities. (Courtesy Frank A. Almquist Collection.)

POSTCARD HISTORY SERIES

Kingston

Patricia O'Reilly Murphy with Friends of Historic Kingston

ARCADIA
PUBLISHING

Published by Arcadia Publishing
Charleston, South Carolina

Printed in the United States of America

Library of Congress Control Number: 2012947140

For all general information contact Arcadia Publishing at:
Telephone 843-853-2070
Fax 843-853-0044
E-mail sales@arcadiapublishing.com
For customer service and orders:
Toll-Free 1-888-313-2665

Visit us on the Internet at www.arcadiapublishing.com

This book is dedicated to my grandfather and my father, from whom I first learned to love local history through the regional postcards they published and distributed.

William M. O'Reilly (1871–1938)
William J. O'Reilly (1905–1996)

CONTENTS

ACKNOWLEDGMENTS

We are grateful to the following for entrusting their postcard collections to Friends of Historic Kingston for this book: Frank A. Almquist, Edwin M. Ford, Dr. Wilson Meaders, Dr. William B. Rhoads, the family of the late Margaret O'Reilly Paulson, and Friends of Historic Kingston.

Deep gratitude is also extended to those who provided or clarified historical information: City of Kingston historian Edwin M. Ford, Dr. William B. Rhoads, and the Kingston Model Railroad Club. Jane Kellar, executive director of Friends of Historic Kingston, is to be commended for fostering the publication of this book.

INTRODUCTION

Positioned midway on the legendary Hudson River, Kingston played a pivotal role in the birth of New York State. The third oldest city in New York, it was founded in 1652 when five families left the Rensselaerwyck Patroon upriver to farm the fertile flood plains bordering the Esopus Creek on the northwest edge of Kingston, where a band of the Algonquin Nation, the Esopus Indians, also had their maize fields. Farming side by side led to misunderstandings between the two groups that mounted to violence, bringing them to the brink of war.

In 1658, Peter Stuyvesant, director-general of the New Netherland Colony, ordered the settlers to move to a central location and surround it with a stockade. He selected a site on a bluff whose height on three sides afforded natural protection and designed a street plan for the new village he named Wiltwyck. The settlers built a 14-foot-high stockade made of eight-inch-diameter trees to enclose it, then took their houses and barns apart board by board, carted them uphill from the lowlands, and reconstructed them within the confines of the fortified village.

Today, Stuyvesant's original street plan is still intact, and the area, designated as the Stockade National Historic District, constitutes the largest extant early Dutch settlement in New York State. Along its streets can be found more than twenty 18th-century limestone houses built by the descendants of Kingston's earliest European settlers, who were mostly Dutch.

In 1777, the State of New York was born in this neighborhood when its fledgling government, chased by British troops up the Hudson River Valley, fled to Kingston. New York State's first elected senate met in the 1676 home of Abraham Van Gaasbeek, which still stands, and the assembly met in the nearby Bogardus Tavern, now demolished. In the original Ulster County Courthouse, the New York State Constitution was written and adopted; New York's first governor, George Clinton, took the oath of office; and Justice John Jay presided over the first session of the New York State Supreme Court. Within view of the courthouse, the Old Dutch Churchyard is the final resting place of Gov. George Clinton.

Reviled by British general John Vaughan as a "nursery for every villain in the country," every building but one in uptown Kingston was burned by the British on October 16, 1777, to punish the city for hosting the new state government. But the sturdy limestone walls withstood fire, and the buildings were reconstructed and still stand as testament to the mettle of the villagers.

The downtown waterfront area of Kingston developed as a separate village called Rondout. One of only three deepwater ports along the Hudson River, Kingston Landing, as it was first called, was the scene of maritime activity from the 17th century, when Dutch sloops delivered goods and left loaded with farm produce. In 1825, when construction on the Delaware & Hudson Canal began on the Rondout Creek, a village suddenly mushroomed. Waves of immigrants,

mostly Irish and German, poured in, along with entrepreneurs, both groups seeking to ride the tide of prosperity promised by the canal. In this microcosm of the Industrial Revolution, other businesses burgeoned: boat building, brick making, cement mining, and bluestone quarrying and shipping. In 1849, Rondout incorporated as a village, and by 1855, with 6,000 residents, it surpassed the uptown village of Kingston in population. In 1870, Rondout reached its peak of prosperity when three million tons of coal were shipped on the canal. In 1871, Rondout petitioned Albany to designate it as a city, but Kingston, alarmed that the more populous village might upstage it, proposed that the two villages unite. On May 29, 1872, the two villages were incorporated as the City of Kingston. To appease the populations of both, land between the villages was selected as the site on which to build a new city hall.

A grand Italian Renaissance–style building opened in 1875 and still serves as the seat of city government. Over the next several decades, midtown developed as a civic center, with the New York State Armory, Kingston Hospital, Kingston Library, Kingston High School, and central US Post Office locating in the neighborhood.

Just as Rondout reached its peak of prosperity, the train whistle sounded the alarm that a black cloud was beginning to form. In 1873, the tracks of the Wallkill Valley Railroad reached Kingston, cutting through the city's center. Factories, manufacturing a variety of goods from lace to cigars and can openers, mushroomed in the neighborhood near the railroad station, and midtown also developed into the city's industrial heartland. Most numerous were garment factories, many of which continued to operate into the 1960s.

Rail transportation, faster and cheaper than boat, led to the closing of the Delaware & Hudson Canal in 1898, ushering in Rondout's slow decline over the next 60 years. In the 1960s, urban renewal forced most of the population to move from Rondout, and its east side was totally razed. But in 1982, in recognition of its role as a major transportation center, Kingston was designated as one of New York State's first Urban Cultural Parks, now called Heritage Areas.

A generation later, Rondout's downslide has been reversed, and the waterfront hums with activity again. In the place of the boat yards that built tugs and barges, marinas filled with pleasure boats line the Rondout Creek, and Kingston is a port of call for many cruise ships. Upscale restaurants, art galleries, and boutiques fill the 19th-century storefronts once occupied by first- and second-generation immigrants.

Kingston's uptown business district is also being reinvented to fill the spaces left void by the flight of retail businesses to the malls. The first floors of former retail stores are filled with a mix of restaurants, realtors, art galleries, food shops, and financial institutions. The honeycomb of upper-story offices are largely being filled with graphic designers, website designers, and people engaged in digital media.

One of the most significant changes in the city's character is the presence of an ever-increasing art community, with former factory spaces being utilized as studios and galleries. A new wave of "immigrants" seeking asylum from the pace of metropolitan life and able to carry on business by telecommuting are also settling throughout the city, attracted by its diversity of architecture. Kingston has four historic districts in the state and national registers. Today, the city's population is approximately 23,000.

Postcards can be said to be the instant messaging of the late 19th and early 20th centuries. A single photograph conveyed a brief but vivid message about the scene it portrayed. The Friends of Historic Kingston hope that the postcards selected to be included in this book will convey a message of the significance of the city of Kingston in New York State history that we work to preserve as an organization.

One

UPTOWN KINGSTON
THE 1658 STOCKADE NATIONAL
HISTORIC DISTRICT

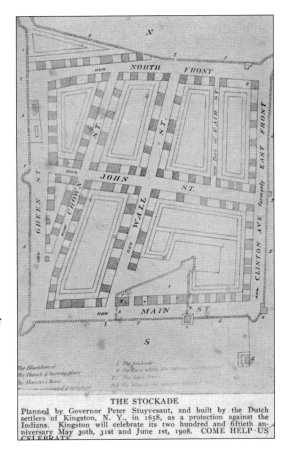

Kingston is the third oldest city in New York State. In 1658, Peter Stuyvesant, director-general of the New Netherland Colony, designed the street plan for the fortified village he named Wiltwyck. The heart of uptown Kingston, the street grid still exists today as the Stockade National Historic District and is the largest intact early Dutch settlement in New York State. Today, twenty-one 18th-century limestone houses still stand within the Stockade District. (Courtesy Edwin M. and Ruth Ford Collection.)

THE STOCKADE.
Planned by Governor Peter Stuyvesant, and built by the Dutch settlers of Kingston, N. Y., in 1658, as a protection against the Indians. Kingston will celebrate its two hundred and fiftieth anniversary May 30th, 31st and June 1st, 1908. COME HELP US CELEBRATE.

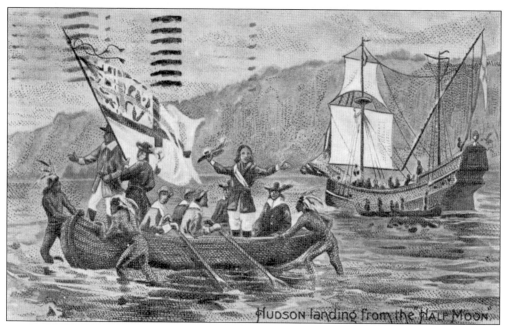

HUDSON landing from the HALF MOON

In September 1609, Henry Hudson, an English explorer hired by the Dutch to find a new route to China, instead found the river that now bears his name. His ship, the *Half Moon*, navigated the river as far north as Albany, resulting in the territory being claimed as a colony by the Dutch and named New Netherland. (Courtesy Edwin M. and Ruth Ford Collection.)

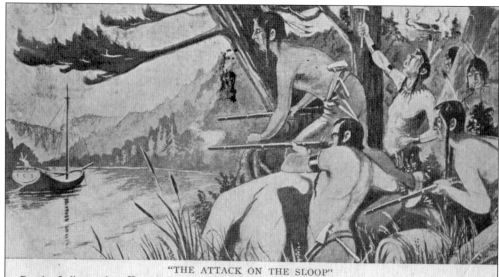

"THE ATTACK ON THE SLOOP"

By the Indians, when Harmon Jacobson was killed, which led to the building of the stockade in Kingston, N. Y., for protection from the Indians May 31st, 1658. Kingston will celebrate the two hundred and fiftieth anniversary of this event May 30th, 31st and June 1st, 1908. A hearty welcome to you to our celebration.

The Esopus Indians, a small tribe of the Algonquin Nation, had fished and farmed in the area for hundreds of years. Friction arose when the first European settlers arrived between 1652 and 1653 and began farming bordering fields. Two wars took place between 1659 and 1664. (Courtesy Frank A. Almquist Collection.)

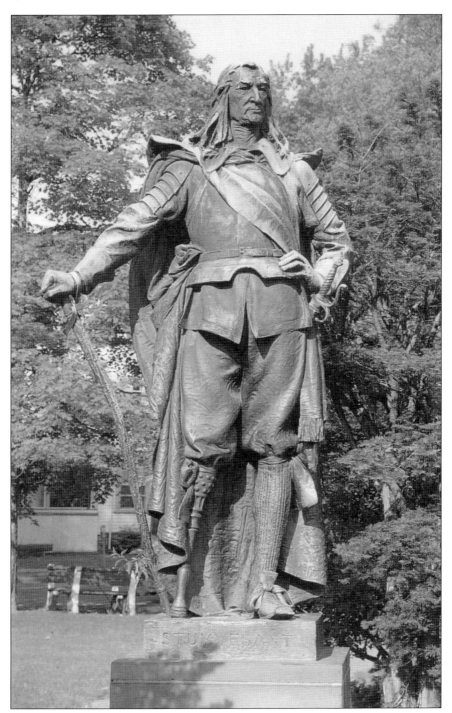

On July 15, 1660, on the Academy Green where his statue now stands, Peter Stuyvesant and the Esopus Indians signed a peace treaty "under the sky of heaven," ending the First Esopus War. The Second Esopus War, which started on June 7, 1663, ended with a treaty signed on May 16, 1664. As a sign of their desire for peace, the Esopus Indians presented Stuyvesant with a wampum belt that is preserved in the Ulster County Archives. (Courtesy Frank A. Almquist Collection.)

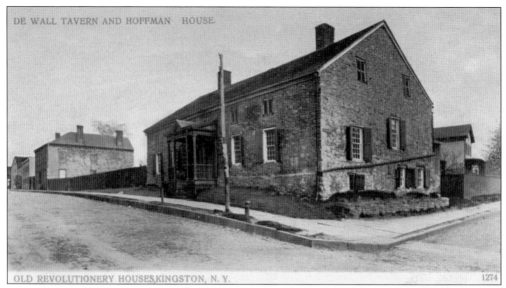

The Hoffman House stood in the northwest corner of the 1658 stockade. The earliest portion was possibly built in the late 17th century, and the house remained in the Hoffman family until the 1920s. In 1977, it was rescued from being demolished by Kingston residents who bought and restored it, converting it into a popular tavern and restaurant. (Courtesy Dr. William B. Rhoads Collection.)

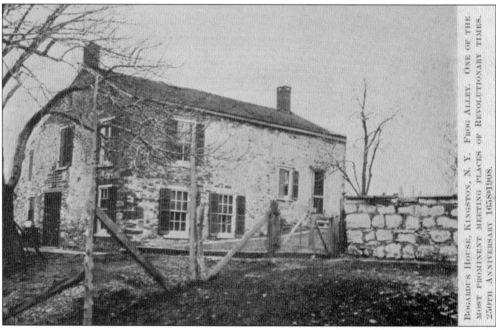

Just outside the northwest corner of the stockade, the Louw–Bogardus House shows the simplicity of an early settler's home. The section on the right was built in the late 17th century. Roofless today as a result of a fire in the 1960s, the ruin has been stabilized by the Friends of Historic Kingston, who rescued it from being razed by urban renewal in 1975. It stands in Frog Alley Park, which is owned and maintained by the Friends of Historic Kingston. (Courtesy Frank A. Almquist Collection.)

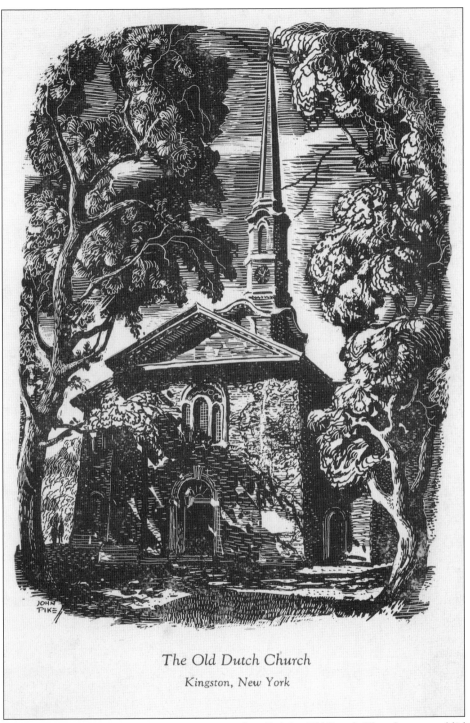

The Old Dutch Church
Kingston, New York

The First Reformed Church of Kingston, commonly called the Old Dutch Church, was established in 1659 and is the oldest religious institution in the city. Until the 1830s, it was also the only church building in Kingston. This sketch of the current church, built in 1852 of native bluestone, was done by noted Woodstock artist John Pike. (Courtesy Edwin M. and Ruth Ford Collection.)

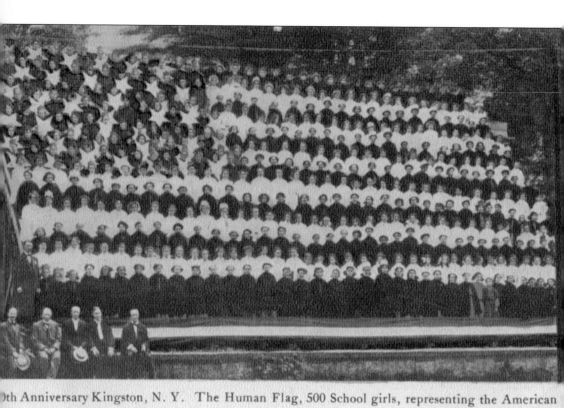

Five hundred young women, draped in red, white, and blue capes, formed a human flag of the United States on the lawn of Kingston City Hall on May 30, 1908, as part of the three-day celebration of the 250th anniversary of Kingston's founding in 1658. (Courtesy Frank A. Almquist Collection.)

Many postcards, some humorous, were designed and printed for Kingston's celebration of its 250th birthday. Oddly, the iconography on the two cards pictured on this page contains no historical references to Kingston. (Courtesy Frank A. Almquist Collection.)

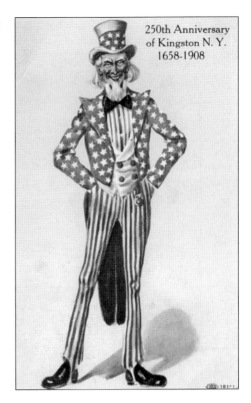

The choice of nationally known symbols such as Uncle Sam, the Statue of Liberty, and Lady Liberty may have been attempts to boost the stature of the 250th celebration of Kingston's founding beyond its local boundaries. (Courtesy Frank A. Almquist Collection.)

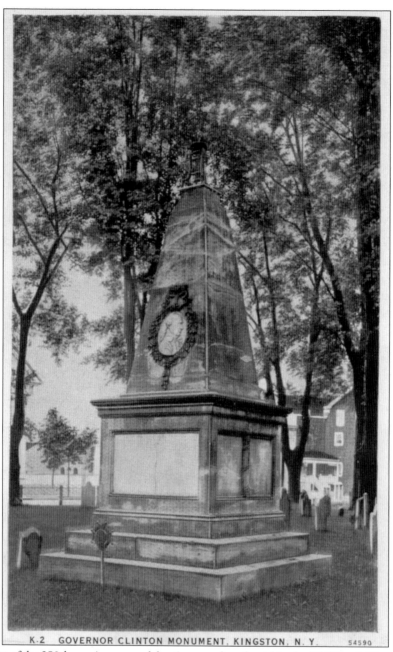

K-2 GOVERNOR CLINTON MONUMENT, KINGSTON, N.Y. 54590

A highlight of the 250th-anniversary celebration was the reburial in the Old Dutch Churchyard of the remains of George Clinton, New York State's first elected and longest serving governor—21 years. Governor Clinton died on April 20, 1812, in Washington, DC, while serving as vice president of the United States under James Madison, a position he also held under Thomas Jefferson. He was buried in the Congressional Cemetery, but a century later, the Kingston citizenry requested that his remains be returned "home" to the city where he had taken the oath of office as governor and had spent considerable time. He and his wife, Cornelia Tappen of Kingston, worshipped at the Old Dutch Church. The monument, which weighs nine tons, was also moved from Washington, DC. (Courtesy Margaret O'Reilly Paulson Collection.)

16

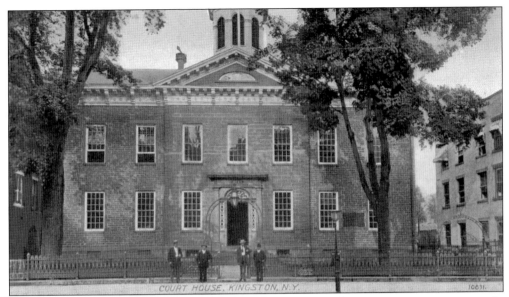

In 1777, chased from New York City up the Hudson by British troops, a state government in formation convened in several buildings in uptown Kingston. In that neighborhood, the Stockade District, New York State was officially born. The New York State Constitution was written and adopted on April 20, 1777, in the original Ulster County Courthouse on this site on Wall Street. New York's first elected governor, George Clinton, took the oath of office on July 30, 1777, and John Jay presided over the first session of the state supreme court here also. The courthouse pictured was built in 1818. (Courtesy Edwin M. and Ruth Ford Collection.)

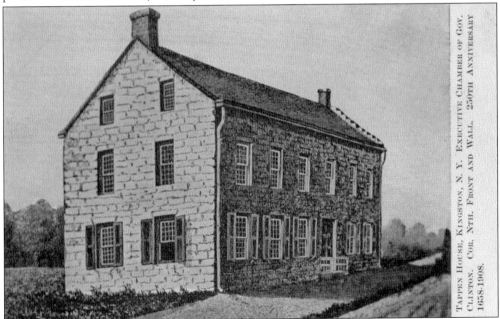

This was the home of Peter Tappen and Tjaaje Wynkoop, parents of Cornelia Tappen, wife of Gov. George Clinton. It served as the governor's executive chambers when he was in Kingston. The limestone house stood on the northwest corner of Wall and North Front Streets but was demolished. (Courtesy Friends of Historic Kingston Archives, Herman Boyle Collection.)

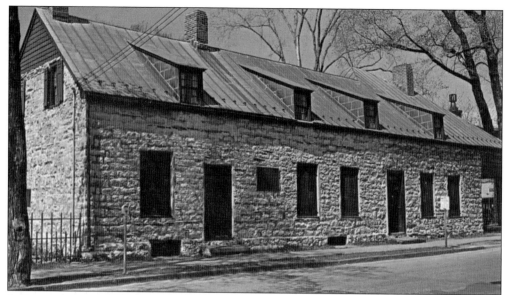

In September and October 1777, New York State's first elected senate met in this house, the residence of merchant Abraham Van Gaasbeek on East Front Street, now Clinton Avenue. The original portion of the simple Dutch vernacular-style limestone house was built in 1676 by Wessel Ten Broeck, but additions on both sides of the center doorway brought it to its current size. Deeded to New York State by Ten Broeck descendants in 1887, it is the second oldest New York State Historic Site. (Courtesy Friends of Historic Kingston Archives, Herman Boyle Collection.)

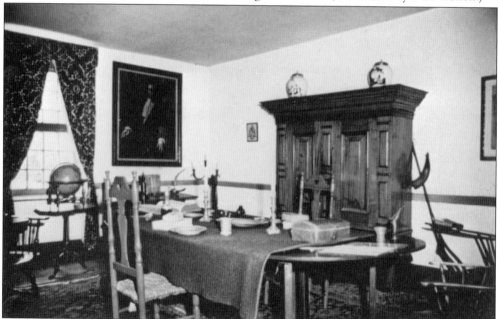

At the end of the Van Gaasbeek house with its own access to the street, this is thought to be the room in which the first elected New York State Senate held its meetings. The Assembly met a few blocks away in the Bogardus Tavern, on the northwest corner of Fair Street and Maiden Lane, but the building no longer stands. (Courtesy Friends of Historic Kingston Archives, Herman Boyle Collection.)

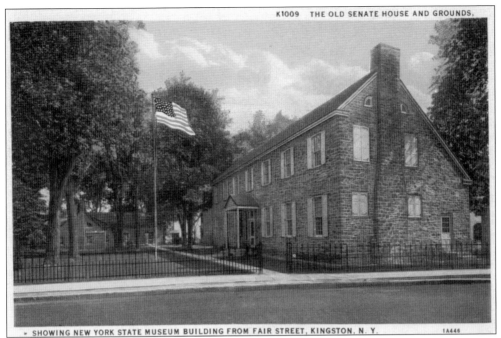

SHOWING NEW YORK STATE MUSEUM BUILDING FROM FAIR STREET, KINGSTON, N. Y. 1A446

Built in 1927, the Senate House Museum was designed to resemble a larger version of a typical Kingston stone house at the time of the American Revolution. The museum contains a notable collection of paintings by Kingston artist John Vanderlyn (1775–1852). (Courtesy Friends of Historic Kingston Archives, Herman Boyle Collection.)

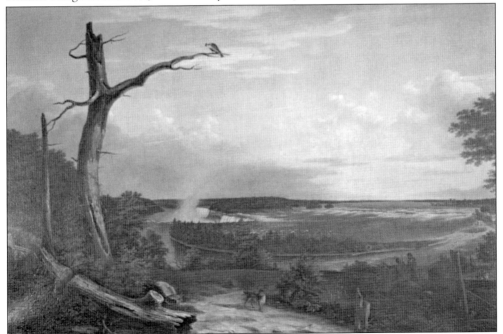

View of Niagara is among the works that hang in the Vanderlyn Gallery in the Senate House Museum. Vanderlyn was the first American artist to study in Paris and to venture beyond portraiture and history paintings. (Courtesy Frank A. Almquist Collection.)

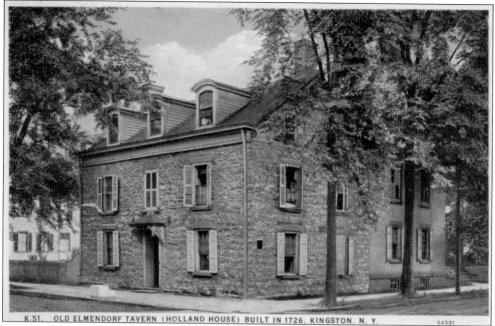

The Elmendorf Tavern, built in 1725 on the southeast corner of Maiden Lane and Fair Street, was the meeting place for the Committee of Safety, the local governing body during the American Revolution. Today, the historic old stone house is a private residence. (Courtesy Friends of Historic Kingston Archives, Herman Boyle Collection.)

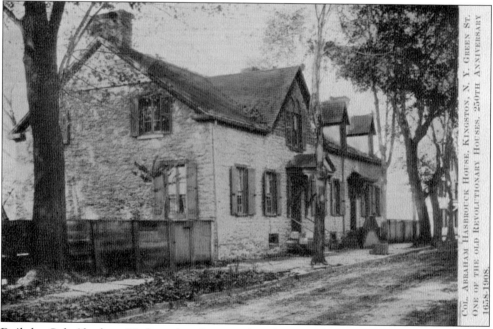

Built by Col. Abraham Hasbrouck, who served with the Northern Militia of Ulster County during the American Revolution, the house at 135 Green Street retains the original flat-panel shutters with hand-wrought iron hardware and Dutch doors. The double house is nicknamed "Kingston's first duplex" and contains apartments. (Courtesy Frank A. Almquist Collection.)

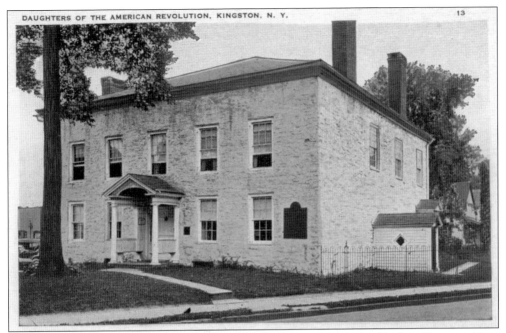

At the intersection of Crown and Green Streets, the home of Henry Sleight, the village president in 1777, was one of the nearly 400 buildings burned by the British on October 16, 1777. In 1909, the badly deteriorated building was bought by the Daughters of the American Revolution (DAR), Wiltwyck Chapter, and restored by Kingston architect Myron Teller. It still serves as the DAR's chapter house. (Courtesy Frank A. Almquist Collection.)

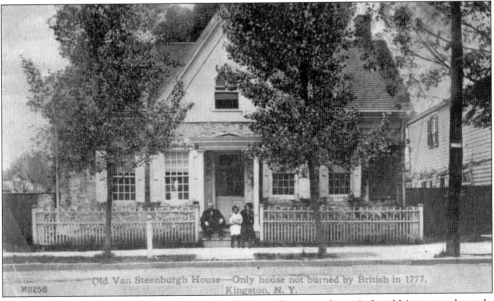

Old Van Steenburgh House—Only house not burned by British in 1777, Kingston, N. Y.

MII258

The Tobias Van Steenburgh House, at 97 Wall Street, has gone down in local history as the only house not burned by the British when they torched uptown Kingston in retaliation for hosting the government of the new State of New York. Several reasons for why it was spared have become part of local folklore. Most likely, the British were unaware that the house, in the woods and a mile from uptown Kingston, even existed. (Courtesy Dr. Wilson Meaders Collection.)

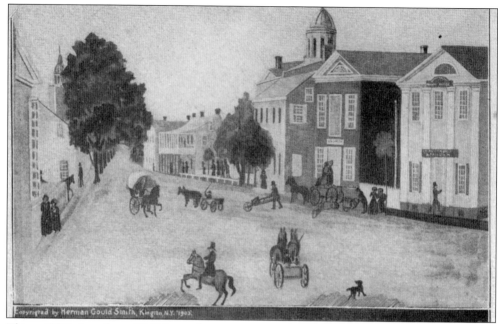

This c. 1830 view shows Wall Street from Main Street to John Street, where it once ended. The cupola-topped Ulster County Courthouse can be seen in the center, and at the end of the block on the right is the c. 1812 John Sudam House, now the Fred J. Johnston Museum and headquarters for the Friends of Historic Kingston. In 1828, Wall Street was extended from John Street to North Front Street, and over the next several decades, the area developed into a bustling commercial center. (Courtesy Friends of Historic Kingston Archives, Herman Boyle Collection.)

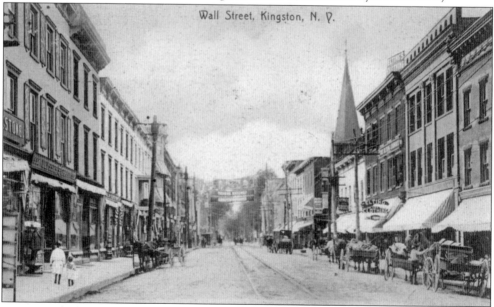

This early hand-colored postcard shows Wall Street filled with commercial buildings from John Street to North Front Street. St. John's Episcopal Church, whose steeple rises on the right, is seen wedged between commercial buildings. Horse-drawn wagons are still the most common mode of transportation at this time. (Courtesy Frank A. Almquist Collection.)

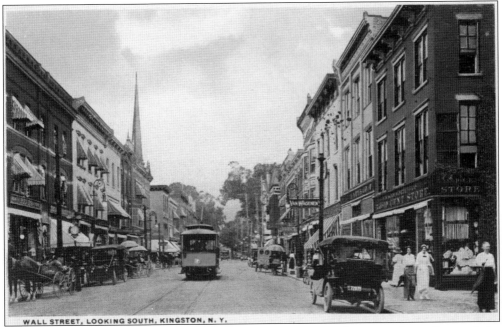

WALL STREET, LOOKING SOUTH, KINGSTON, N. Y.

This later postcard shows three modes of transport—horse and wagon, the trolley, and the automobile—bringing shoppers to Wall Street's stores. Electric trolley car transportation in Kingston started in 1892, when two competing companies began operating—the Kingston City Electric Railway Company and the Colonial City Railway Company. (Courtesy Frank A. Almquist Collection.)

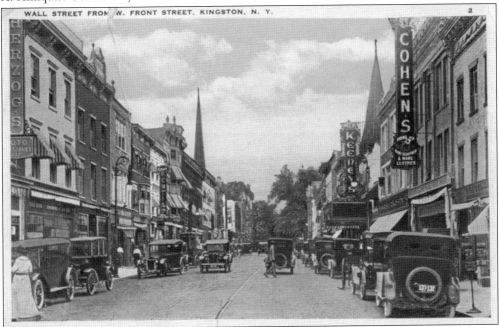

WALL STREET FROM W. FRONT STREET, KINGSTON, N. Y.

The first automobile was driven on Kingston streets in 1900, but by the early 1920s, cars had replaced horses and wagons on Wall Street. In the 1970s, Wall Street was changed to one-way traffic. (Courtesy Frank A. Almquist Collection.)

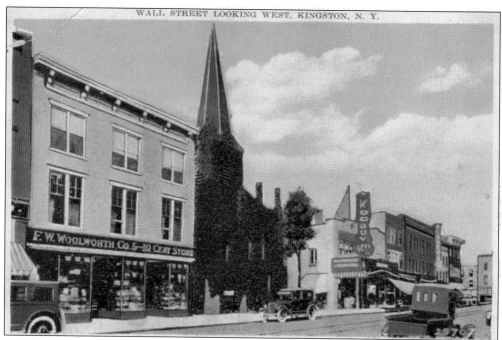

In 1894, Woolworth's opened on the west side of Wall Street between John and North Front Streets. Woolworth's had a popular lunch counter in front and a pet department in the rear, a favorite place for youngsters to buy goldfish. St. John's Episcopal Church is wedged in between two commercial buildings. (Courtesy Friends of Historic Kingston Archives, Herman Boyle Collection.)

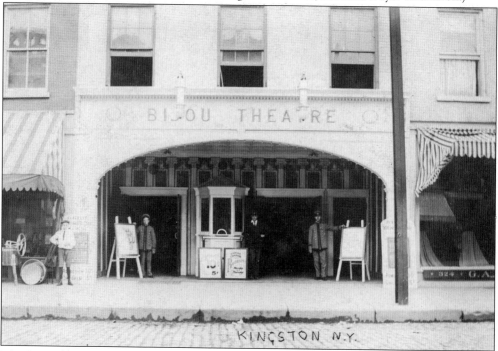

The Bijou Theater opened in 1913 at 326 Wall Street but only operated for about four years. (Courtesy Edwin M. and Ruth Ford Collection.)

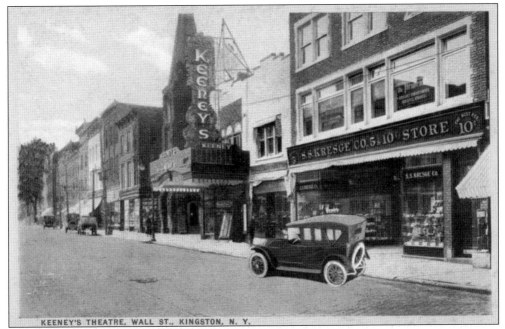

KEENEY'S THEATRE, WALL ST., KINGSTON, N. Y.

Keeney's Theater opened on Wall Street in 1918. On the right, Kresge's joined Woolworth's in the procession of four 10¢ stores lined up in a row on Wall Street's west side. Grant's and Newberry's were the other two. (Courtesy Frank A. Almquist Collection.)

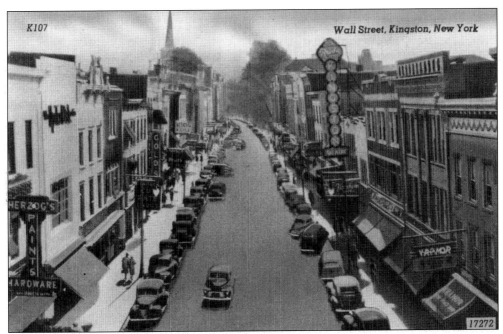

In 1926, the Walter Reade chain bought Keeney's, expanded it, and renamed it the Kingston Theater. Closed in the 1970s, the building was converted into a furniture store, but the stage in the rear was preserved and is still occasionally used for theatrical productions. (Courtesy Friends of Historic Kingston Archives, Herman Boyle Collection.)

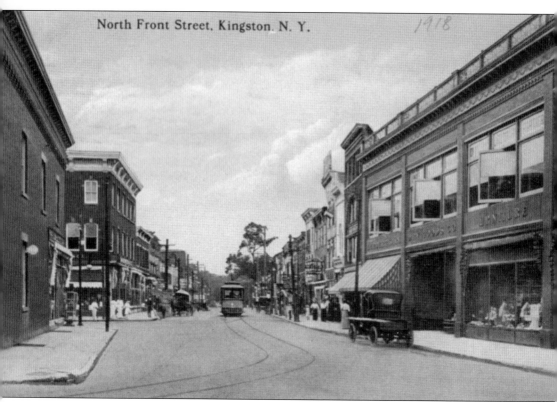

North Front Street, Kingston. N. Y.

1918

Montgomery Ward occupied the building on the right on North Front Street from 1937 until the late 1960s. After the store moved to a mall in the town of Ulster, the building was demolished. A city parking lot currently occupies the site. Montgomery Ward was Kingston's largest department store and the only store at holiday time with a live Santa Claus whom children could visit. (Courtesy Friends of Historic Kingston Archives, Herman Boyle Collection.)

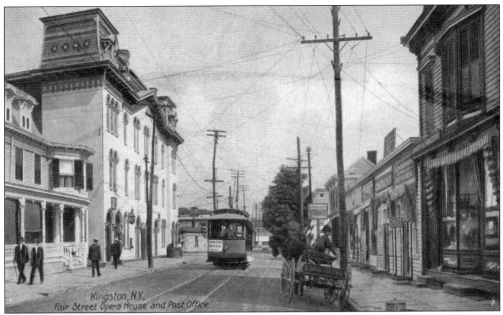

The Kingston Opera House opened in 1850 as the Kingston Music Hall on the corner of Fair and John Streets. The large building on the left, it was designed by J.A. Wood and constructed in 1868–1869. In 1900, the building was converted to retail and office space. Today, its mansard roof and gables gone, the building contains 28 office suites and eight street-level retail spaces. (Courtesy Friends of Historic Kingston Archives, Herman Boyle Collection.)

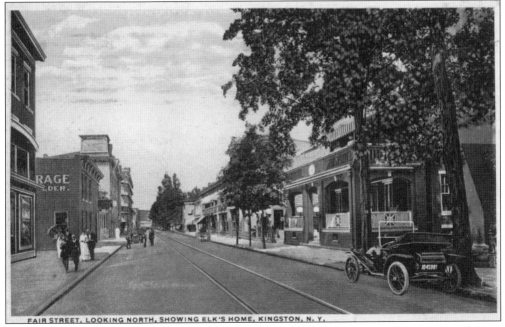

The uptown shopping district extended to Fair Street, which also featured a selection of stores between John and Main Streets. On the right, the headquarters of Elks Lodge No. 550 was demolished in the 1960s, and the lodge moved to 143 Hurley Avenue. (Courtesy Frank A. Almquist Collection.)

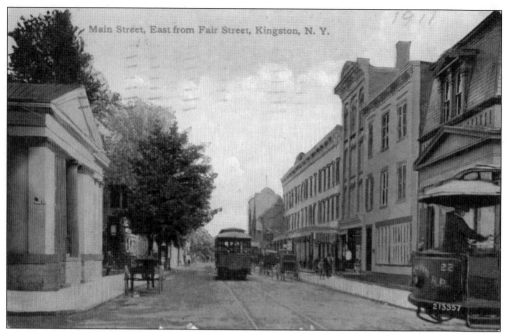

Uptown Kingston developed as a financial center in the 19th century, starting with the opening of the Kingston National Bank in 1839 on the corner of Main and Fair Streets. The Greek Revival–style building has been continuously occupied by banks and is currently a branch of Rhinebeck Savings Bank. (Courtesy Friends of Historic Kingston Archives, Herman Boyle Collection.)

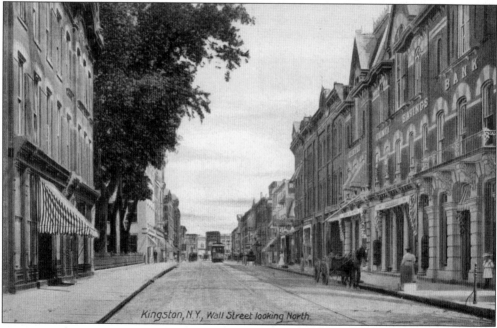

The home of Ulster County Savings Bank, which now has branches in several counties, has been at 280 Wall Street since 1851. The original building, designed by noted Hudson Valley architect J.A. Wood (1837–1910), was built in 1868–1869 and modified in the 1950s by Harry Halverson. (Courtesy Friends of Historic Kingston Archives, Herman Boyle Collection.)

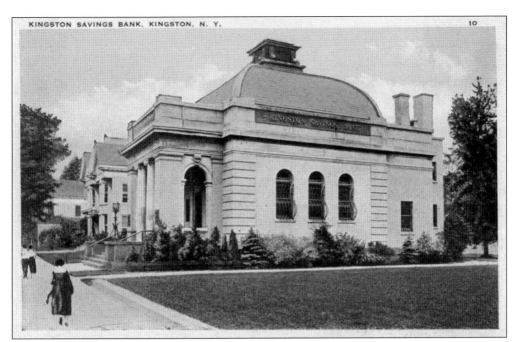

When it was built in 1900, Kingston Savings Bank was designed in the Classical style. The bank still occupies the same site, but in 1960, the original building was radically redesigned by Kingston architect George Hutton. (Courtesy Edwin M. and Ruth Ford Collection.)

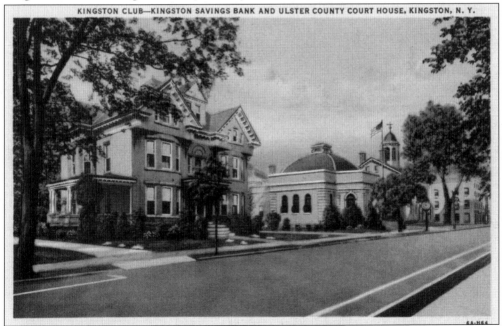

The Kingston Club, formerly on the left side of Kingston Savings Bank on Wall Street, offered evidence that Kingston was prospering. Next door to the Fred J. Johnston House, the private club was open only to men considered to be professionally successful. In 1950, the building became home to the Jewish Community Center, but it was eventually demolished, and Key Bank occupies the site. (Courtesy Dr. William B. Rhoads Collection.)

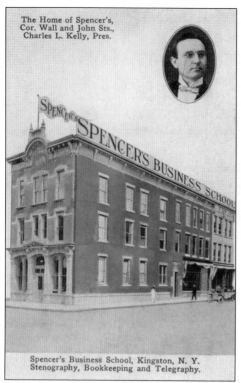

The Home of Spencer's, Cor. Wall and John Sts., Charles L. Kelly, Pres.

Spencer's Business School, Kingston, N. Y. Stenography, Bookkeeping and Telegraphy.

Spencer's Business School, on the northeast corner of Wall and John Streets, offered training in typing, shorthand, bookkeeping, and telegraphy. The school moved to Fair Street around 1918, and the State of New York National Bank relocated to the school's former location. In advertisements, it referred to itself as "the Red Bank" to distinguish itself from the National Ulster County Bank and Trust Company directly opposite, which called itself "the White Bank." Currently, the building is owned and occupied by the Hudson Valley LGBQT Center. (Courtesy Frank A. Almquist Collection.)

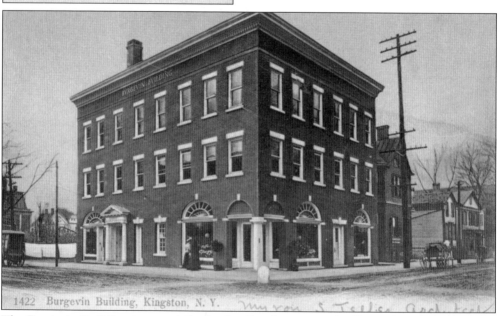

1422 Burgevin Building, Kingston, N. Y.

The Burgevin Building is named for the family who operated a florist shop on the ground floor for nearly a century and had its own greenhouses on upper Pearl Street. Burgevin family members commissioned noted Kingston architect Myron Teller to design the building, which was constructed in 1904–1905 in the Georgian Revival style. A florist shop still operates on the first floor, while the upper two floors hold offices and apartments. (Courtesy Friends of Historic Kingston Archives, Herman Boyle Collection.)

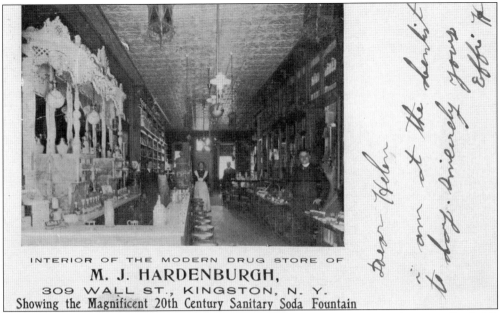

INTERIOR OF THE MODERN DRUG STORE OF
M. J. HARDENBURGH,
309 WALL ST., KINGSTON, N. Y.
Showing the Magnificent 20th Century Sanitary Soda Fountain

The "magnificent 20th century sanitary soda fountain" in "the modern drug store" of M.J. Hardenburgh, shown in this 1905 photograph, was one of many in the uptown business district. Soda fountain counters were made of marble, and hot fudge for topping sundaes was a standard favorite. The site remained a soda fountain, luncheonette, pharmacy, and popular uptown gathering place operated by the Nekos family until 2010. (Courtesy Frank A. Almquist Collection.)

The City Garage, opposite the Kirkland Hotel on Clinton Avenue, was more familiarly known as "Doc Smith's Garage." On the reverse of the postcard, besides offering repairs of every kind, "Doc" advertised that he was the headquarters for Blue Sunoco motor fuel, which "snaps cold motors into instant action." He also sold DeSotos and had 150 parking spaces, no doubt for customers of the four hotels in the neighborhood. (Courtesy Edwin M. and Ruth Ford Collection.)

Meyer's Jewel Box occupied a space at 40 John Street that was as small as its name suggests. When this card was published in the 1950s, Meyer's had already been in business for 42 years, but it no longer exists. (Courtesy Frank A. Almquist Collection.)

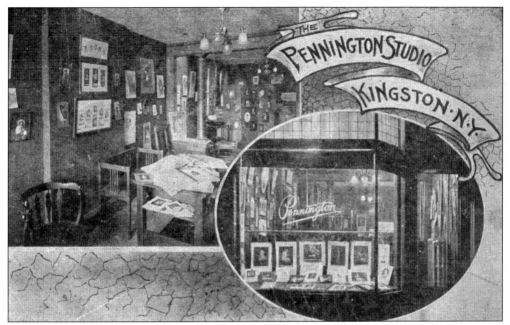

One of Kingston's prestigious photography studios, Pennington's, at 72–74 Main Street, mailed postcards like the one shown to tell customers that their work was ready for pickup. Another noted photographer in uptown Kingston was Lipgar's on Fair Street, later occupied by photographer Tom Reynolds. (Courtesy Friends of Historic Kingston Archives, Herman Boyle Collection.)

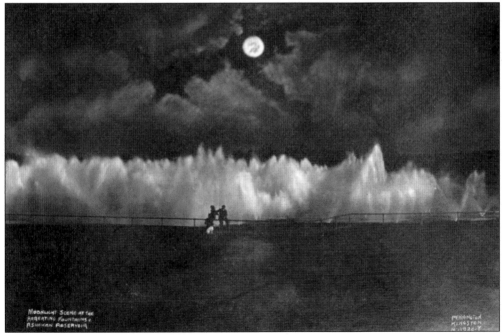

This image of the moon over the aerator at the Ashokan Reservoir offered dramatic evidence of the quality of a Pennington photograph to prospective clients. The back of the postcard contains a list of statistics about the reservoir and promotes the photograph as "ideal for Christmas gifts." (Courtesy Friends of Historic Kingston, Herman Boyle Collection.)

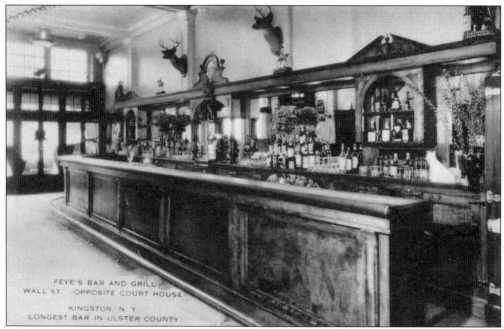

Faye's Bar and Grill, opposite the courthouse on Wall Street, claimed to be famous not only for seafood, but also for having the longest bar in Ulster County. This 1936 postcard shows the polished wood bar with the traditional brass rail running along the bottom. (Courtesy Frank A. Almquist Collection.)

Hoppey's succeeded Faye's in the same space at 286 Wall Street and advertised fine steaks, chops, and seafood. The restaurant inherited the "longest bar in the county." (Courtesy Frank A. Almquist Collection.)

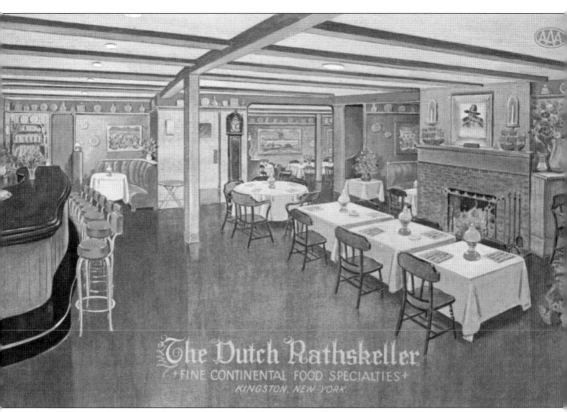

When the Dutch Rathskeller opened in the basement of the Kirkland Hotel in the 1950s, it brought a taste of sophistication to Kingston cuisine. A team of international chefs turned out dishes such as sauerbraten with dumplings and nasi goring. The bar was a popular gathering place. An organist played songs by request and customers sang along, adding to the cheer. (Courtesy Frank A. Almquist Collection.)

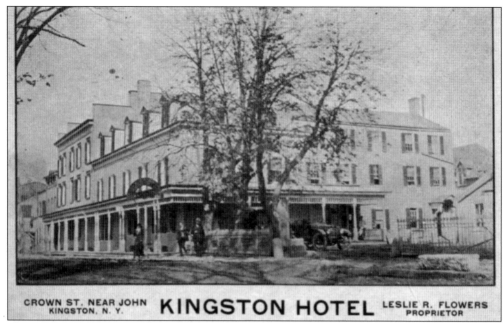

CROWN ST. NEAR JOHN
KINGSTON, N. Y. **KINGSTON HOTEL** LESLIE R. FLOWERS
PROPRIETOR

The Kingston Hotel once occupied a large section of the east side of Crown Street between North Front and John Streets. The noted Kingston artist John Vanderlyn died here in 1852. The hotel was destroyed in stages, the final portion demolished in 2000. A parking lot fills the void today. (Courtesy Friends of Historic Kingston Archives, Herman Boyle Collection.)

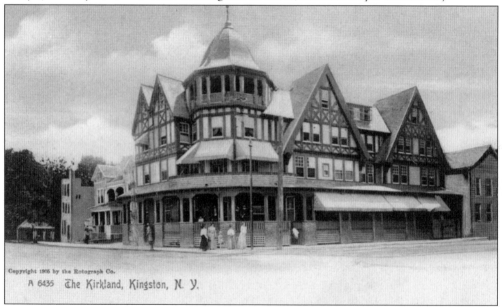

Copyright 1905 by the Rotograph Co.
A 6435 The Kirkland, Kingston, N. Y.

The half-timbered Tudor-style Kirkland Hotel opened in 1899 as a boardinghouse but became a hotel 18 years later. Under the ownership of Max and Ruth Brugmann, it was the home of the popular Dutch Rathskeller from 1952 to 1972. Empty for more than 30 years, the building was threatened with demolition until it was restored by the nonprofit Rural Ulster Preservation Corporation (RUPCO). It reopened in 2005, offering a mix of commercial and residential spaces. (Courtesy Friends of Historic Kingston Archives, Herman Boyle Collection.)

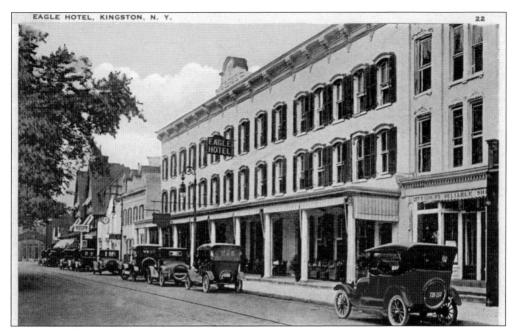

The Eagle Hotel stood on the south side of Main Street between the Kirkland Hotel and the current Ulster County Office Building. A long porch lined with rocking chairs stretched the length of the hotel front, allowing guests to enjoy the street scene. Today, the site is occupied by a county parking lot. (Courtesy Friends of Historic Kingston Archives, Herman Boyle Collection.)

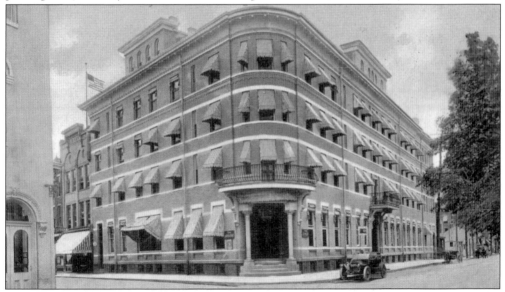

Named for the famous director-general of New Netherland (1642–1664), Peter Stuyvesant, who designed the original street plan for uptown Kingston, the Stuyvesant Hotel opened in 1911 on the northwest corner of John and Fair Streets. Its 150 rooms, advertised as the most modern in the Hudson Valley, featured hot and cold water, electric lights, and long-distance telephone service. Restored by RUPCO in 1993, it now offers 40 apartments for the elderly and people with disabilities, office space for RUPCO, and a restaurant. (Courtesy Friends of Historic Kingston Archives, Herman Boyle Collection.)

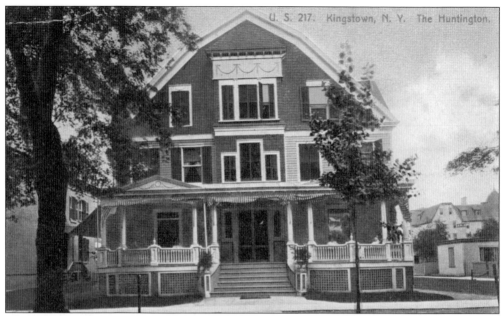

The Huntington, formerly at 23 Pearl Street, was built by Ezra H. Fitch, grandson of William and Simeon Fitch, large wholesalers of Ulster County bluestone. More of an upscale boardinghouse, it served permanent residents. It was demolished in the 1960s, and the property was converted to a parking lot for Ulster County employees and clients of the county departments housed in that block. Ezra H. Fitch formed the clothing company Abercrombie & Fitch. (Courtesy Frank A. Almquist Collection.)

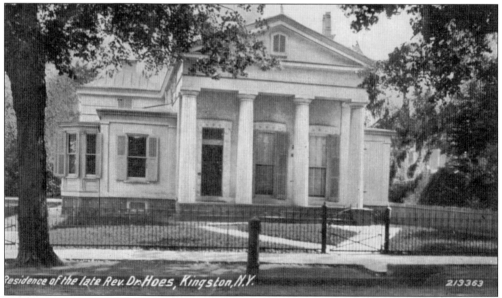

Art historian Dr. William B. Rhoads considers The Columns to be the best example of a Greek Revival–style house in Kingston. Built for James B. Weeks around 1839 at 26 Pearl Street, opposite the Huntington Hotel, it is identified on postcards as the residence of Reverend Dr. John C.F. Hoes, who bought the house in 1867, when he retired as domine of the Old Dutch Church. (Courtesy Dr. William B. Rhoads Collection.)

Standing prominently in the Old Dutch Churchyard, this statue, called *Patriotism, Daughter of the Regiment*, was dedicated by Gen. George H. Sharpe to the 120th Regiment of New York State, which he commanded during the Civil War. The famous regiment took part in almost every major battle from Fredericksburg to Appomattox, and the names of the battles it fought are listed on the statue's base. It was unveiled on October 17, 1896, and is the only known monument and cemetery plot in the United States deeded to a group of soldiers by their commander. (Courtesy Frank A. Almquist Collection.)

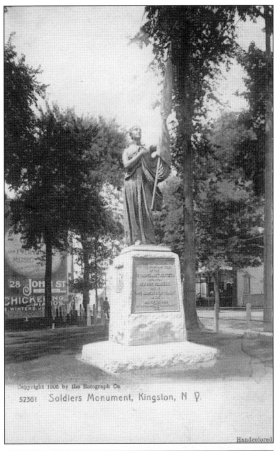

Copyright 1906 by the Rotograph Co.
52361 Soldiers Monument, Kingston, N. Y. Handcolored

The home of Gen. George H. Sharpe stood on Albany Avenue near the corner of Clinton Avenue but was moved to the rear of the property in 1924 so that the Governor Clinton Hotel could be built on the site. (Courtesy Edwin M. and Ruth Ford Collection.)

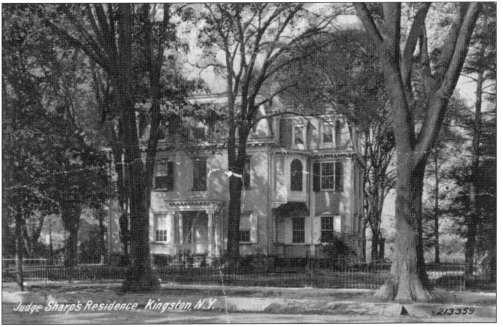

Judge Sharpe's Residence, Kingston, N.Y. 213359

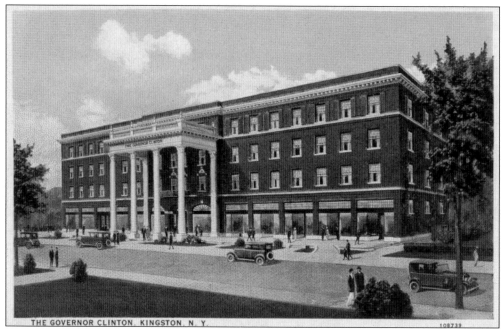

THE GOVERNOR CLINTON, KINGSTON, N. Y.

Erected from 1924 to 1926, the Governor Clinton Hotel was designed in the Georgian Revival style by Kingston architect George E. Lowe. The hotel's grand entrance, with its three-story-high columns, declared architecturally that this was the place to stay. The hotel's Crystal Room was considered the choice place for wedding receptions and also hosted class reunions, dances, and weekly meetings of service clubs such as Rotary. In the 1980s, the hotel was converted to offices on the ground floor and senior apartments on the upper three floors. (Courtesy Dr. Wilson Meaders Collection.)

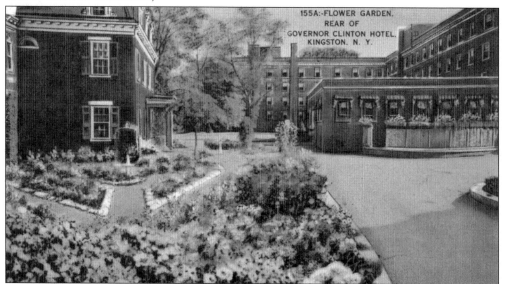

155A:-FLOWER GARDEN. REAR OF GOVERNOR CLINTON HOTEL, KINGSTON. N. Y.

This rear view of the Governor Clinton Hotel shows the former residence of Gen. George Sharpe on the left, which became the hotel annex after the house was moved from its original site. General Sharpe's horse, Babe, is said to be buried beneath the hotel kitchen on the right. (Courtesy Frank A. Almquist Collection.)

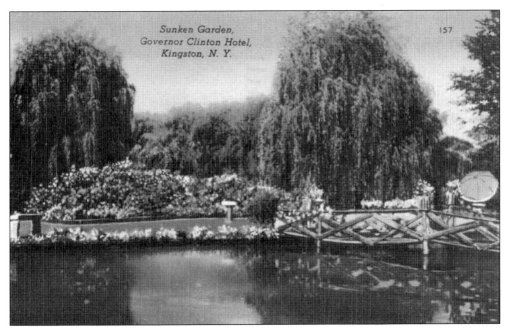

Sunken Garden,
Governor Clinton Hotel,
Kingston, N. Y.

157

The magnificent sunken gardens behind the Governor Clinton Hotel were renowned and were a favorite setting for wedding parties to be photographed. Today, there is no sign of the gardens, and the rear of the former hotel is paved with asphalt for a parking lot. (Courtesy Margaret O'Reilly Paulson Collection.)

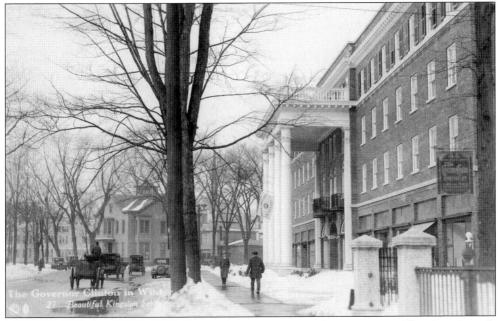

Holiday time at the Governor Clinton Hotel was trumpeted by the appearance of illuminated angels holding musical instruments on the iron balcony over the hotel's front door. During the holiday season, the Governor Clinton was the scene of several annual social events, such as the Assembly Dances and Bachelors and Spinsters Ball. This postcard is part of a series of art photographs by L.E. Jones of Woodstock, New York. (Courtesy Edwin M. and Ruth Ford Collection.)

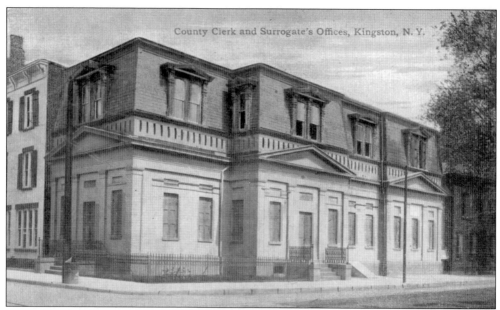

County Clerk and Surrogate's Offices, Kingston, N. Y.

Kingston has served as the seat of government for Ulster County since Colonial times. The Ulster County Clerk and Surrogate's Office were located on same site as the current Ulster County Office Building on the southeast corner of Fair and Main Streets. The mansard-roofed structure was demolished in the early 1960s to make way for the new county office building. (Courtesy Frank A. Almquist Collection.)

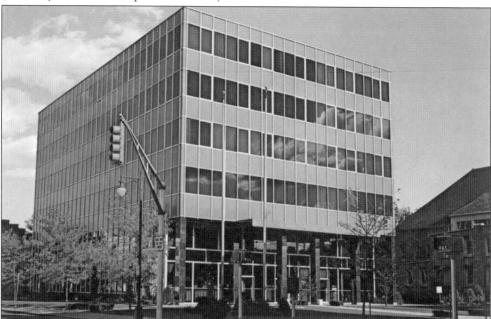

The Ulster County Office Building was Kingston's first "big glass box," and its modern design aroused considerable controversy when it was selected over a more traditional Colonial Revival design. The building was dubbed the "Glass Menagerie" by WGHQ owner Harry Thayer, who delivered on-air diatribes about this travesty of architecture nearly every day. (Courtesy Friends of Historic Kingston Archives, Herman Boyle Collection.)

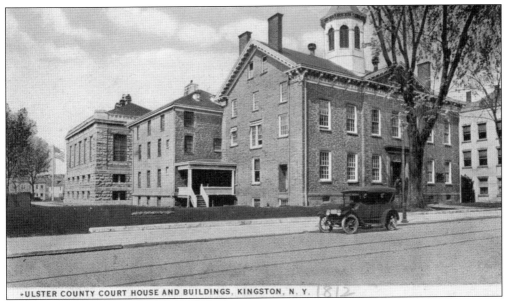

The Ulster County Courthouse, at 285 Wall Street, was built in 1818 on the same site as the courthouse where the New York State Constitution was written and adopted in 1777. History was made in this courthouse when nationally known abolitionist Sojourner Truth, a former Ulster County slave, sued for and won her young son's freedom from slavery in Alabama. The county jail, designed by Kingston architect Myron Teller and built of locally quarried limestone, was added to the rear in 1899. (Courtesy Margaret O'Reilly Paulson Collection.)

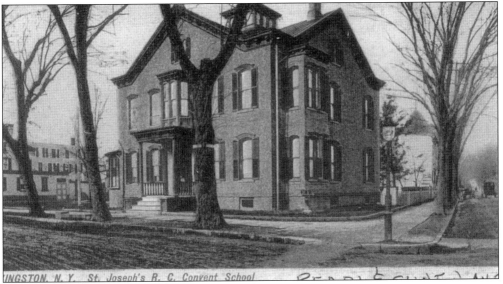

Over the past several decades, Ulster County offices have expanded to former private residences on Pearl Street. Judge Alton B. Parker, the Democratic candidate for president of the United States against Theodore Roosevelt in 1904, was the most famous resident of 1 Pearl Street, built in 1872. In 1905, it was bought by St. Joseph's Parish and used as school and convent until 1912, when it was sold to A. Carr and Son and became a funeral home for many years. It was threatened with being demolished before being bought for county offices in the 1980s. (Courtesy Frank A. Almquist Collection.)

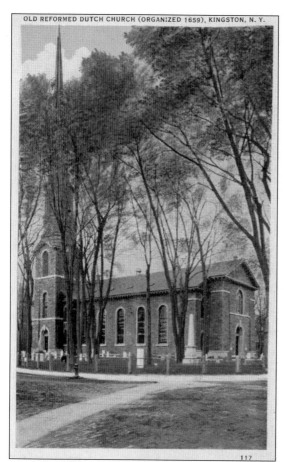

Only one year younger than the city itself, the First Reformed Protestant Dutch Church of Kingston, commonly called the Old Dutch Church, was organized in 1659. The present 1852 church edifice, the congregation's third building, was designed in the English Renaissance style by a noted New York ecclesiastical architect, Minard Lefever, and built of locally quarried bluestone. A visual landmark in uptown Kingston, the Old Dutch Church holds the distinction of being named a National Historic Landmark. (Courtesy Frank A. Almquist Collection.)

The interior of the Old Dutch Church evokes the architecture of Christopher Wren's St. Paul's Cathedral in London and the New Church in Delft, Holland, with its ribbed, vaulted ceiling and simulated clerestory windows. The stained-glass window in the rear was designed and installed by Louis Comfort Tiffany in 1891. As was customary with Tiffany, Thomas Edison installed the back lighting. (Courtesy Frank A. Almquist Collection.)

117

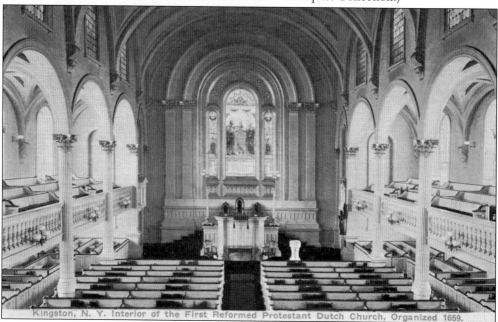

Kingston, N. Y. Interior of the First Reformed Protestant Dutch Church, Organized 1659.

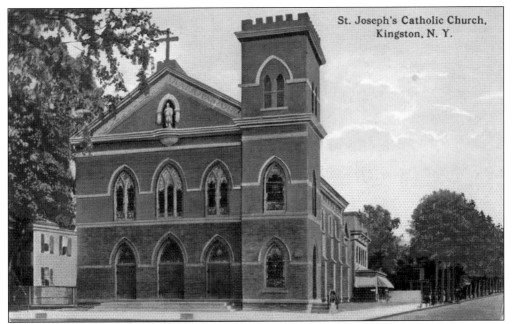

St. Joseph's Catholic Church, Kingston, N. Y.

Hidden behind the Gothic-style front of St. Joseph's is a brick Greek Revival–style church built by the Old Dutch Church in 1832 to replace a smaller limestone one across the street. When the congregation moved in 1852 to its present location, the building became the Kingston Armory. In 1869, St. Joseph's bought the building and hired prominent Hudson Valley architect J.A. Wood to convert the drill hall into a church again. On July 27, 1869, mass was celebrated for the first time in the building used to train troops a few years prior. In 1898, a vestibule, bell tower, and Gothic facade were added, giving the church its present appearance. (Courtesy Frank A. Almquist Collection.)

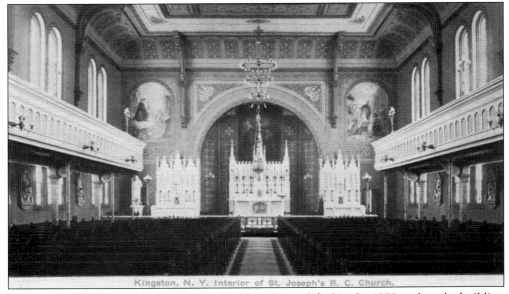

Kingston, N. Y. Interior of St. Joseph's R. C. Church.

The interior of St. Joseph's Church was significantly modified in the 1970s, when the building underwent an extensive restoration. The side balconies shown here were removed as well as the murals and ornate Gothic-style main and side altars. (Courtesy Frank A. Almquist Collection.)

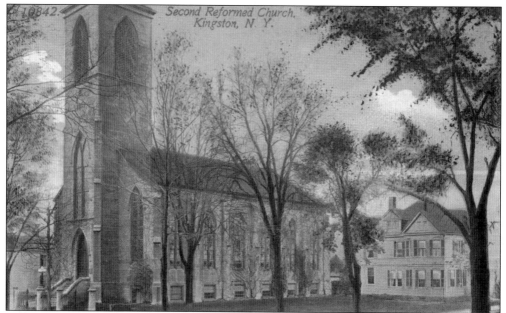

The Second Reformed Dutch Church, at 209 Fair Street, was founded by members who seceded from the First Dutch Church in 1850, and their choice of Gothic Revival architecture may have been a bold statement of their declaration of independence. The limestone used in the building came from Luke Noone's quarry on upper Pearl Street, where rock outcroppings are still very visible. The church steeple toppled in 1854. (Courtesy Frank A. Almquist Collection.)

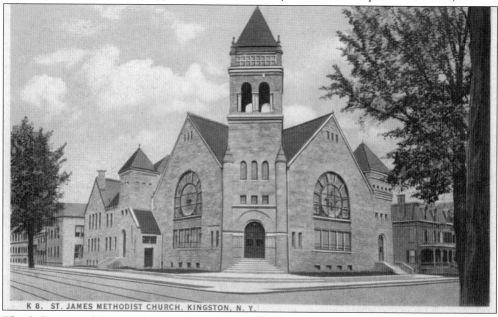

The dedication of the new St. James Methodist Episcopal Church on the northeast corner of Fair and Pearl Streets drew the attention of the *New York Times*, which gave the event 12 paragraphs in the January 14, 1894, edition with the headline "Kingston's Handsome New Church." The building's hallmarks are its massive moss-colored stone walls with two huge stained-glass windows and its pyramid-shaped bell tower. (Courtesy Margaret O'Reilly Paulson.)

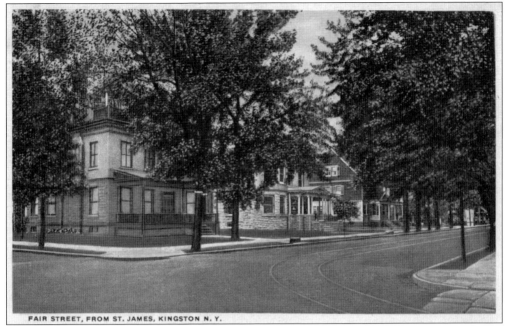

FAIR STREET, FROM ST. JAMES, KINGSTON N. Y.

Beginning about 1850, affluent businessmen began to build large residences near the uptown business district. A long line of distinguished homes in various architectural styles appeared over the next several decades on Fair Street. Significant examples of Colonial Revival, Italianate, Second Empire, and Greek Revival led to Fair Street being designated one of Kingston's four historic districts. (Courtesy Frank A. Almquist Collection.)

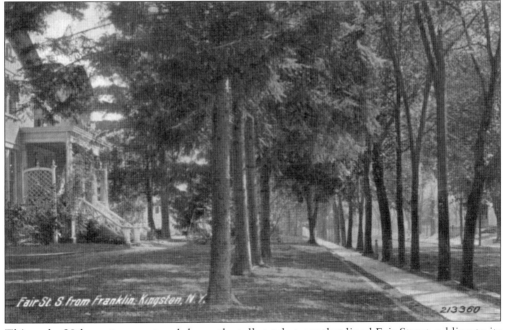

This early-20th-century postcard shows the tall stately trees that lined Fair Street, adding to its appeal as an upscale residential neighborhood. While some Kingston streets have lost their old trees, many still stand on Fair Street. (Courtesy Frank A. Almquist Collection.)

At the start of the 20th century, a triangular piece of land stood at the junction of Albany Avenue and Broadway. At its tip stood Garbarino's Market, a favorite place to buy fresh fruits, vegetables, and Christmas trees. In 1959, that short stretch of street, along with the commercial buildings on it, were demolished, as well as several large homes on Albany Avenue, to construct a new intersection to connect with the newly built Col. Chandler Drive (I-587). (Courtesy Friends of Historic Kingston Archives, Herman Boyle Collection.)

In 1803, long before homebuilding began with a frenzy on Albany Avenue, Jacob Ten Broeck built a large limestone house in which he lived until his death in 1829. The next owner was Peter Sharp, who also owned the land across the street that became the Sharp Burying Ground. The Friends of Historic Kingston have been restoring the cemetery since 1995. A 20th-century Ten Broeck House resident was John Schoonmaker, owner of Island Dock, Inc., a major shipbuilding concern in Rondout until the 1950s. (Courtesy Frank A. Almquist Collection.)

48

In the 1870s, Albany Avenue, broad and lined with tall, arching trees, gained stature as one of the choicest streets in Kingston on which to buy property and build a residence. The building of homes began at the end near Broadway and gradually spread northward. (Courtesy Frank A. Almquist Collection.)

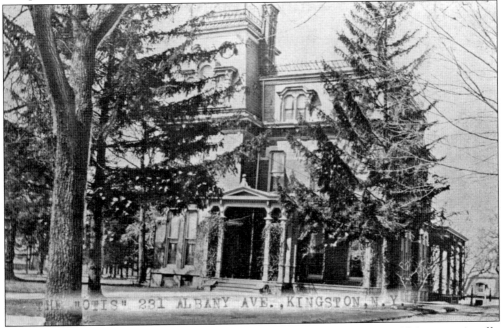

Trees partially hide the Second Empire–style house at 231 Albany Avenue with its exceptionally tall iron-crested mansard roof and rounded windows that look like large eyes. Henry Otis, considered Kingston's leading builder in 1875, constructed the house as his own residence, but it also served to show off his professional skill. Still standing, the house has been converted into apartments. (Courtesy Frank A. Almquist Collection.)

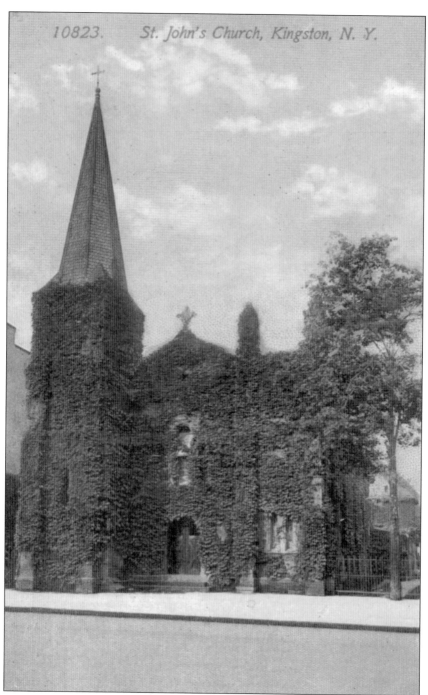

St. John's Episcopal Church, at 207 Albany Avenue, was originally erected in 1835 at 319 Wall Street, but by the 20th century, it was wedged between Woolworth's on the right and Keeney's Theater on the left. In 1926, the Walter Reade chain offered $100,000 for the land so it could expand the theater building it now owned. The church was taken down, the stones numbered, and the facade of the building reerected at 207 Albany Avenue in front of a wider structure. (Courtesy Edwin M. and Ruth Ford Collection.)

Two

MIDTOWN KINGSTON
THE CIVIC CENTER

In 1872, the rival villages of uptown Kingston and downtown Rondout united. To placate both populations, a site for Kingston City Hall was selected midway between the villages and a competition held to select an architect. The winner, Arthur Crooks of New York City, designed a building whose tower closely resembled the Palazzo Vecchio in Florence, Italy. The fortress-like building opened in 1875. Severely damaged by fire in 1927, the tower was simplified when rebuilt. In 1972, Kingston City Hall was vacated for a new structure in Rondout, and the building was left to deteriorate for nearly 30 years. In 2000, beautifully restored under Mayor T.R. Gallo, Kingston City Hall reopened at 420 Broadway, and city government moved back. (Courtesy Friends of Historic Kingston Archives, Herman Boyle Collection.)

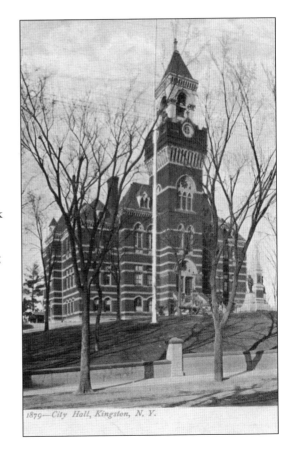

1879—City Hall, Kingston, N. Y.

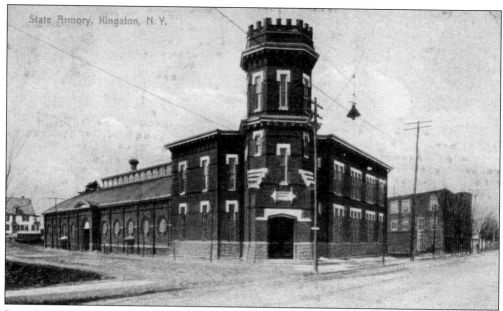

State Armory, Kingston, N. Y.

Locating Kingston City Hall in midtown launched the development of a civic center in that area. On April 16, 1880, the New York State Armory opened just two blocks away at 467 Broadway. A festive opening included a dinner and a ball at which the band played until 4:00 a.m. After the state constructed a new armory on North Manor Avenue, the City of Kingston gained possession of the building in 1933 and renamed it the Municipal Auditorium. Dances, shows, boxing matches, and Kingston High School basketball games were held there. In 1982, it was renamed the Midtown Neighborhood Center, and it is home to the Kingston Recreation Department. (Courtesy Edwin M. and Ruth Ford Collection.)

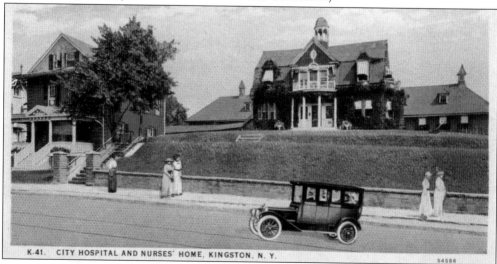

K-41. CITY HOSPITAL AND NURSES' HOME, KINGSTON, N. Y.

On November 27, 1894, Kingston Hospital opened its doors to its first patients in a two-story wood building right next door to Kingston City Hall at 396 Broadway. One year later, on February 20, 1926, a fire destroyed the main portion of the original hospital, but it was rebuilt and reopened the following year. On the left, the home for student nurses was donated by Mary Augusta Coykendall, widow of the noted entrepreneur Samuel D. Coykendall. (Courtesy Edwin M. and Ruth Ford Collection.)

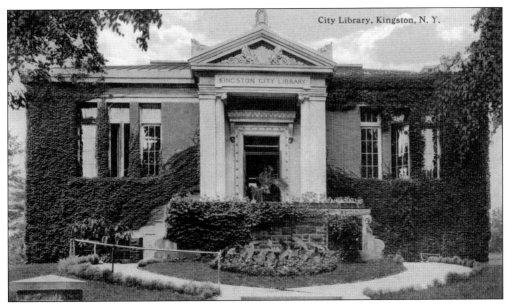

In 1904, the Kingston City Library opened in its own building at 399 Broadway, opposite Kingston City Hall, where it had occupied space before it had its own home. It was designed by a noted Brooklyn architect, Raymond Almirall, and received $30,000 in Carnegie funds towards its erection. Vacant for many years after the library moved to larger quarters, the building was restored and reopened in October 2011 and appropriately named the Carnegie Center for Creative Learning. (Courtesy Dr. William B. Rhoads Collection.)

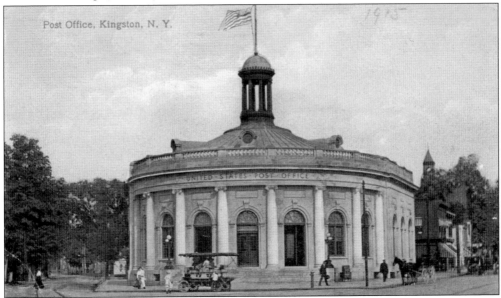

The emerging civic center in midtown gained an impressive addition with the erection between 1904 and 1908 of the Central Post Office on the corner of Broadway and Prince Street. More than three decades later, Kingstonians still mourn the classical-style limestone and granite building razed through December 1969 and January 1970 and replaced with a series of fast-food outlets. Its demise became a powerful rallying cry for not allowing Kingston City Hall to suffer a similar fate. (Courtesy Friends of Historic Kingston Archives, Herman Boyle Collection.)

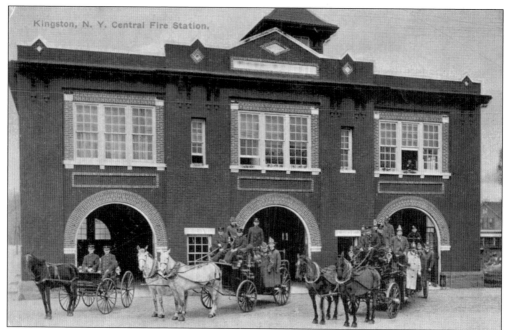

In 1908, the Central Fire Station was built at 19 East O'Reilly Street, at the foot of the hill on which Kingston City Hall sits. Designed by noted Kingston architect Myron Teller (1875–1959), it had dormitory space, baths, recreational rooms, and a chief's office on the second floor, from which firemen could quickly descend sliding down a brass pole. When fire trucks replaced horse-drawn wagons, the doors were made rectangular and widened. The Kingston Department of Public Works and Water Department are in close proximity, forming a municipal cluster. (Courtesy Friends of Historic Kingston Archives, Herman Boyle Collection.)

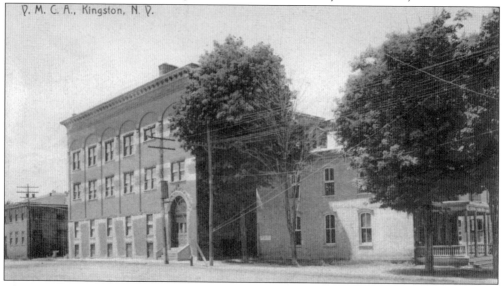

The YMCA has been a fixture on the north corner of Broadway and Pine Grove Avenue since 1898, when it purchased the smaller building on the right, the Grand Central Hotel, for administrative offices. The gym was added on the rear and ready for use in the autumn of 1899. (Courtesy Friends of Historic Kingston Archives, Herman Boyle Collection.)

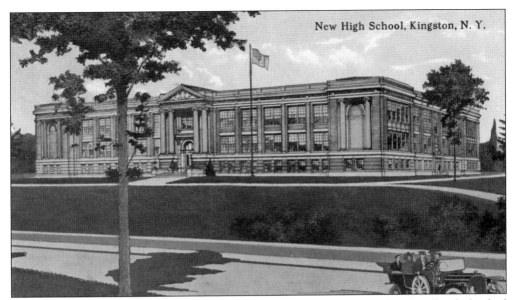

In 1915, Kingston High School opened at 403 Broadway, consolidating the two schools that had served the separate villages—Ulster Academy in downtown Rondout and Kingston Academy uptown. Its classical design, which is modeled on the Louvre Palace in Paris, is the work of Kingston architect Arthur Curtis Longyear (1867–1929), who designed four other Kingston schools shown in chapter 4. The midtown civic center reached its apex with the addition of Kingston High School next to the Kingston Library and opposite Kingston City Hall. (Courtesy Frank A. Almquist Collection.)

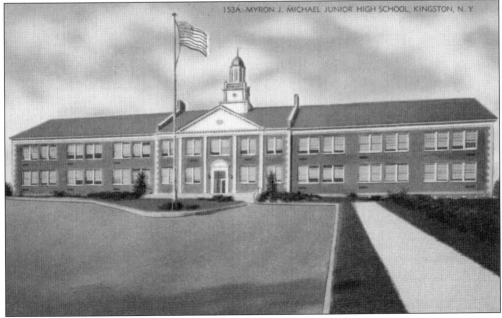

Midtown's civic center expanded when the Myron J. Michael Junior High School was erected directly behind Kingston High School in 1937–1938. It was designed by Myron Teller (1875–1959) and Harry Halverson (1891–1988), the leading architects in Ulster County for the first half of the 20th century. (Courtesy Frank A. Almquist Collection.)

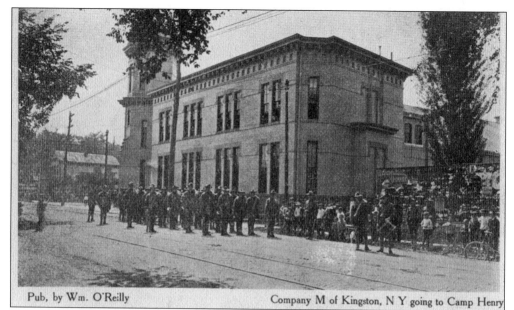

Pub, by Wm. O'Reilly Company M of Kingston, N Y going to Camp Henry

Company M of Kingston was organized in 1874 as Company H, 20th Battalion, National Guard of New York State. Its earliest assignments were suppressing labor riots in Rosendale in 1876 and in Rondout in the summer of 1877. Company M was mustered into service during the Spanish-American War in 1898 and sent to Hawaii. The regiment regularly held its drills at the New York State Armory at 467 Broadway, and sometimes as many as 1,000 spectators turned out to watch. (Courtesy Friends of Historic Kingston Archives.)

A wooden victory arch was erected on Broadway between Kingston City Hall and Kingston High School to honor local World War I servicemen, and the parade held on April 1, 1919, passed under it. A bronze honor roll tablet listing the names of hundreds of local veterans now stands by the wall at Kingston City Hall where the arch once was. (Courtesy Edwin M. and Ruth Ford Collection.)

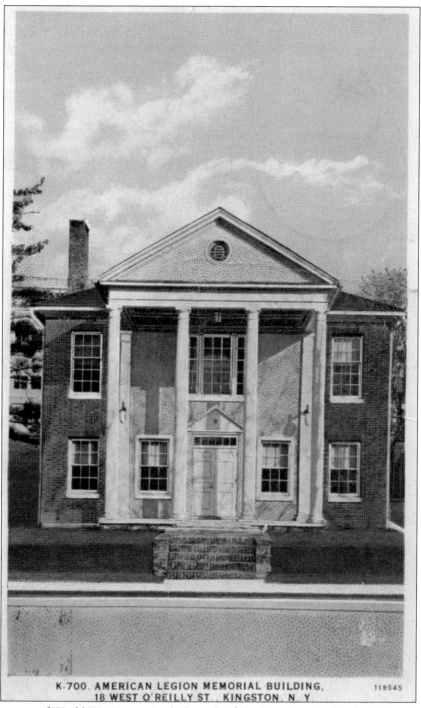

K·700. AMERICAN LEGION MEMORIAL BUILDING,
18 WEST O'REILLY ST., KINGSTON, N. Y.
119545

Local veterans of World War I organized a branch of the American Legion in 1919 and erected a building in 1926 at 18 West O'Reilly Street to memorialize the city's servicemen who died in the war. Designed by Kingston architect Charles S. Keefe (1876–1946), the Colonial Revival American Legion Building stands in view of the honor roll tablet at Kingston City Hall. (Courtesy Friends of Historic Kingston Archives, Herman Boyle Collection.)

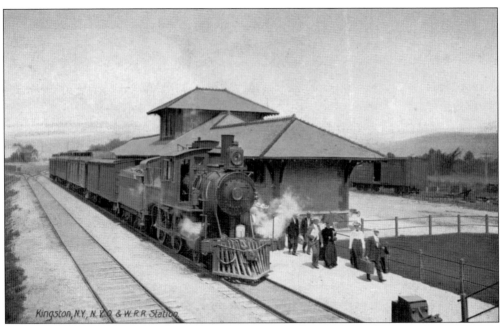

The New York Ontario & Western Railway Station was built in 1902 on Fair Street Extension where Kingston Plaza now stands. The station has been demolished. (Courtesy Dr. William B. Rhoads Collection.)

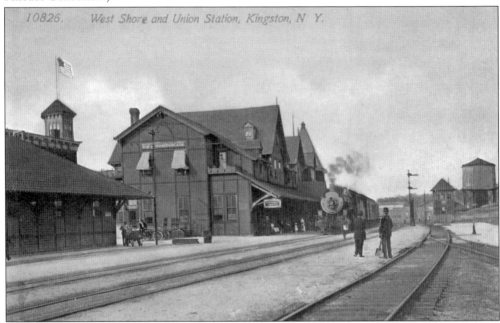

The first railroad, the Wallkill Valley, entered Kingston in 1873. The train station, Union Depot, was built in 1882–1883 to accommodate passengers on the West Shore Line, to whom the Wallkill Valley Railroad was sold. At one time, four railroads provided both passenger and freight service to and from Kingston: Wallkill Valley, New York Ontario & Western, Ulster & Delaware, and the West Shore. The station was demolished in 1949. (Courtesy Edwin M. and Ruth Ford Collection.)

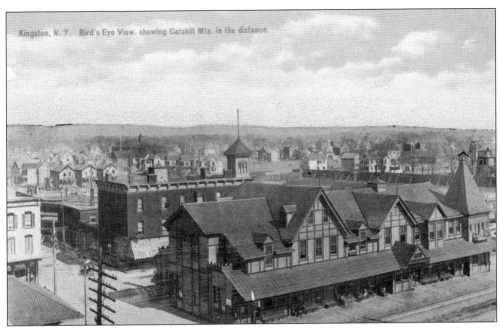

The train depot spurred the commercial growth of midtown Kingston. Many factories were built in the neighboring blocks to take advantage of the shipping facilities in close proximity. Midtown factories manufactured cigars, lace, can openers, and a variety of garments—men's shirts, ladies' dresses, and pajamas. Today, these industrial spaces are being repurposed for other uses. (Courtesy Friends of Historic Kingston Archives, Herman Boyle Collection.)

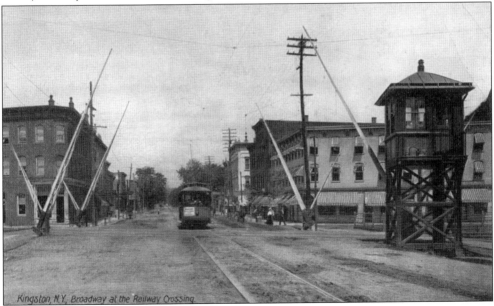

The railroad station also spurred the building of many hotels nearby. The United States Hotel is on the left; the Ulster Hotel is on the right. Both were demolished when an underpass was built in 1949. Traffic on Broadway had to halt many times a day for the passing of trains. The gates were lowered and raised by the gateman in the wooden tower on the right. The underpass eliminated this inconvenience. (Courtesy Dr. William B. Rhoads Collection.)

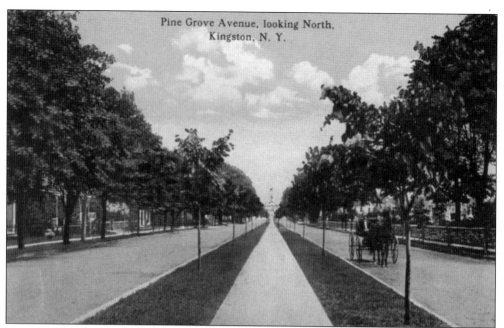

Pine Grove Avenue, looking North, Kingston, N. Y.

This postcard view of Pine Grove Avenue looking north shows a beautiful tree-shaded boulevard lined with residences. At the end of the avenue, the cupola-topped post office can be spied. (Courtesy Friends of Historic Kingston Archives, Herman Boyle Collection.)

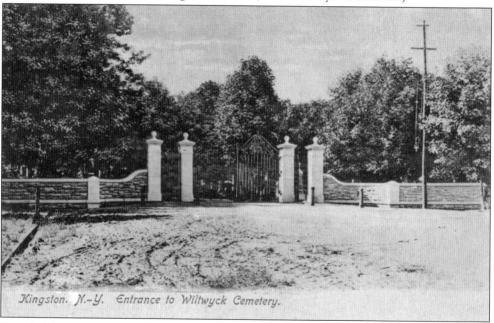

Kingston. N.-Y. Entrance to Wiltwyck Cemetery.

Founded in 1850, Wiltwyck Rural Cemetery, with its winding roadways, was laid out in an idyllic setting with its main entrance at the end of as-yet-undeveloped Pine Grove Avenue. Among the most venerated residents buried there is the nationally noted Kingston artist John Vanderlyn (1775–1852), whose work is represented at the Metropolitan Museum of Art, US Capitol, National Gallery of Art, and Smithsonian American Art Museum. (Courtesy Frank A. Almquist Collection.)

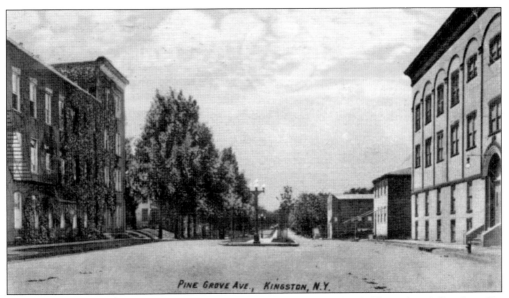

A decade later, a very different view shows Pine Grove Avenue invaded by industrialization. On the left, one of Kingston's several cigar factories, the American Cigar Company, was built in 1891 and had more than 1,000 employees. One of the city's many garment factories, the Fuller Shirt Company, the last building on the right, moved to Pine Grove Avenue in 1903. Fuller's had 500 employees in 1936 and manufactured 1.4 million shirts in one year. (Courtesy Friends of Historic Kingston Archives, Herman Boyle Collection.)

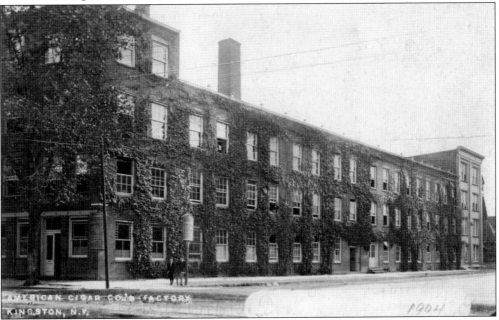

Facing Broadway, the four-story American Cigar Company stretched down Pine Grove Avenue. When it closed, a garment factory occupied the space. By the 1940s, the first floor in front had been removed to convert the space into a bus terminal for Adirondack Trailways. The building was demolished in 1999 to build a Rite-Aid drugstore. (Courtesy Friends of Historic Kingston Archives, Herman Boyle Collection.)

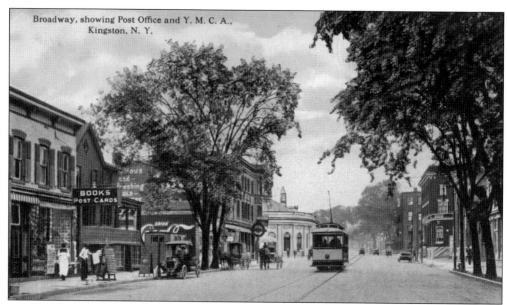

Broadway, showing Post Office and Y. M. C. A., Kingston, N. Y.

On the left, O'Reilly's started as a newsstand at the Union Depot Station in 1888 but moved to the midtown commercial corridor at 530 Broadway around 1898. Among a miscellany of merchandise from firecrackers and bathing slippers to books and stationery items, the store published and distributed many of the Kingston postcards in this book. (Courtesy Friends of Historic Kingston Archives, Herman Boyle Collection.)

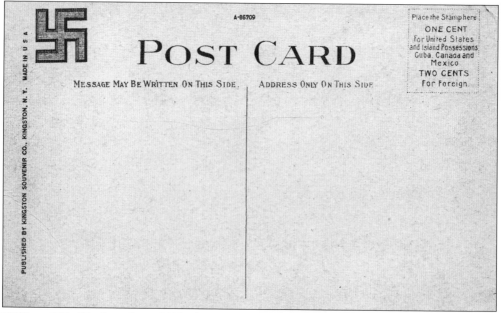

William O'Reilly Sr., who published Kingston postcards, unwittingly chose to put a popular Indian peace symbol on the back side of the cards. Unfortunately, it resembled a swastika but with the arms reversed. During World War II, the FBI ordered that the cards be destroyed. Hundreds of thousands were burned in the furnace in the basement of the store, but many have survived in postcard collections. (Courtesy Friends of Historic Kingston Archives, Herman Boyle Collection.)

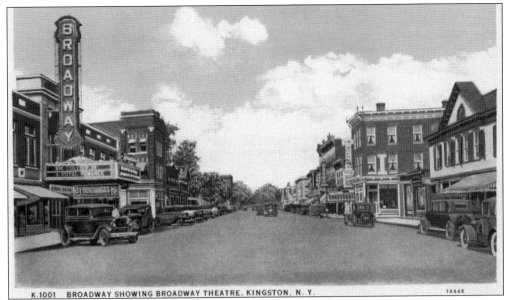

The Broadway Theater opened on June 9, 1927, at 601 Broadway featuring films, vaudeville acts, and live entertainment. After closing in 1977, it was reincarnated as the Ulster Performing Arts Center in 2002, and its classic illuminated marquee was replaced with a Corinthian-columned portico. The building is listed in the National Register of Historic Places. (Courtesy Friends of Historic Kingston Archives, Herman Boyle Collection.)

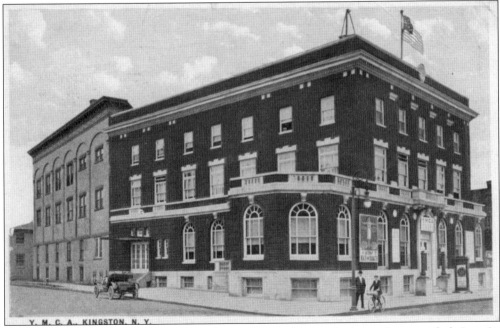

By 1931, the YMCA at Broadway and Pine Grove Avenue had greatly expanded since its beginning in 1898 at the same location. The front building (seen on page 54), once the Grand Central Hotel, has been demolished to make way for a three-story brick structure. Due to a fire and the need to further expand, a new facility was built on the site. (Courtesy Friends of Historic Kingston Archives, Herman Boyle Collection.)

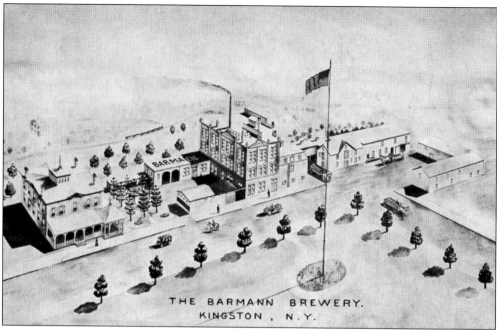

THE BARMANN BREWERY.
KINGSTON, N.Y.

Barmann's Brewery is legendary in local Prohibition-era history for transporting beer secretly through a 2.5-inch hose running through city sewer pipes to a warehouse across town where it was bottled or kegged, then shipped to speakeasies run by the infamous Jack "Legs" Diamond. Unable to recover financially from the Prohibition years, the business was sold in 1938. A ball field occupies the former site on Greenkill and South Clinton Avenues. (Courtesy Friends of Historic Kingston Archives, Herman Boyle Collection.)

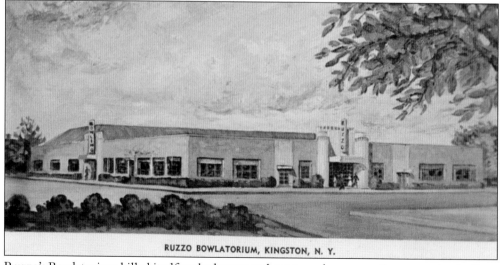

RUZZO BOWLATORIUM, KINGSTON, N. Y.

Ruzzo's Bowlatorium billed itself as the largest and most modern recreation center in the East, featuring 24 bowling alleys, a world championship–style billiard parlor, cocktail lounge, and restaurant. It opened in 1947 and closed in 1953. The large building on Grand Street is now occupied by medical offices. (Courtesy Dr. William B. Rhoads Collection.)

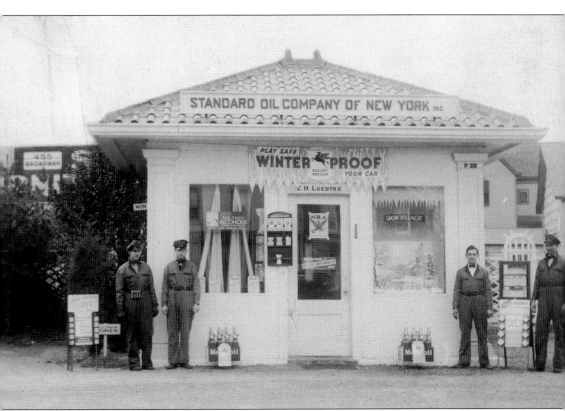

At holiday time, the Socony station, formerly on the corner of Broadway and Hoffman Street, gave this postcard to customers with a seasonal greeting on the reverse side. The photograph on the card evokes the bygone time when a uniformed attendant pumped gas for customers and, as part of the service, cleaned the windows and popped open the car hood to check the oil. The ceramic-tile roof is typical of early-20th-century gas stations. (Courtesy Friends of Historic Kingston Archives.)

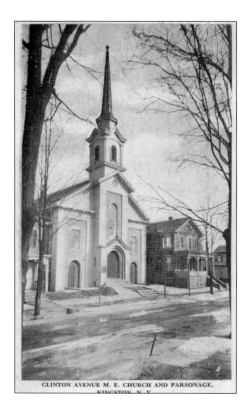

CLINTON AVENUE M. E. CHURCH AND PARSONAGE, KINGSTON, N. Y.

The Clinton Avenue Methodist Church was organized in 1850 as the Wesley Methodist Church of Kingston. The church building at 122 Clinton Avenue was constructed in 1858 and still stands. (Courtesy Friends of Historic Kingston Archives, Herman Boyle Collection.)

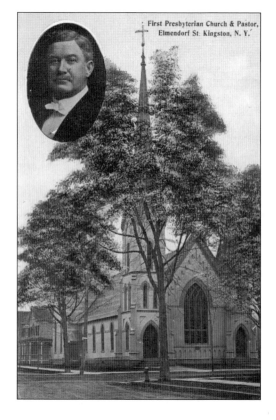

First Presbyterian Church & Pastor, Elmendorf St. Kingston, N. Y.

Erected in 1878 at 80 Elmendorf Street, the Gothic Revival–style First Presbyterian Church was designed by J.A. Wood, the leading architect in the Mid-Hudson region in the 1860s and 1870s. Wood designed several other notable buildings in Kingston, including the Ulster County Savings Bank on Wall Street, Kingston Opera House and Stuyvesant Hotel on the corner of John and Fair Streets, and the New York State Armory (Midtown Neighborhood Center) on Broadway. (Courtesy Friends of Historic Kingston Archives, Herman Boyle Collection.)

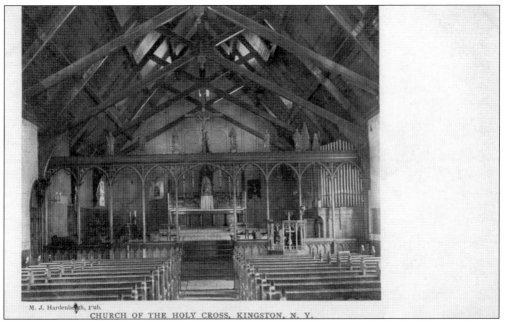

CHURCH OF THE HOLY CROSS, KINGSTON, N. Y.

Holy Cross Episcopal Church was built in 1891–1892 as a mission chapel of St. John's Episcopal Church on Albany Avenue to serve working-class families living near the West Shore Railroad. An elaborately carved 23-foot-high wooden main altar highlights the interior. The church is a choice venue for concerts due to its superior acoustics. (Courtesy Friends of Historic Kingston Archives, Herman Boyle Collection.)

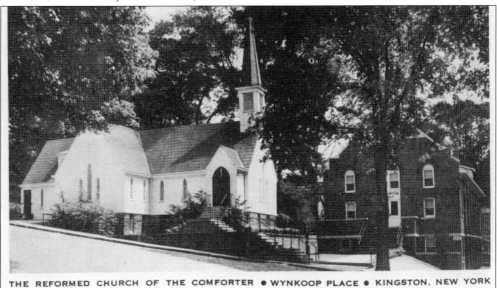

THE REFORMED CHURCH OF THE COMFORTER • WYNKOOP PLACE • KINGSTON, NEW YORK

The location of the Reformed Church of the Comforter seems just right tucked into a hillside on Wynkoop Place, one of Kingston's last cobblestoned streets. The congregation was founded in 1850 by two members of the Old Dutch Church and was originally called the Reformed Dutch Church of Wiltwyck. The church building, erected in 1864 and renovated between 1939 and 1947, is in the shape of a cross. (Courtesy Friends of Historic Kingston Archives, Herman Boyle Collection.)

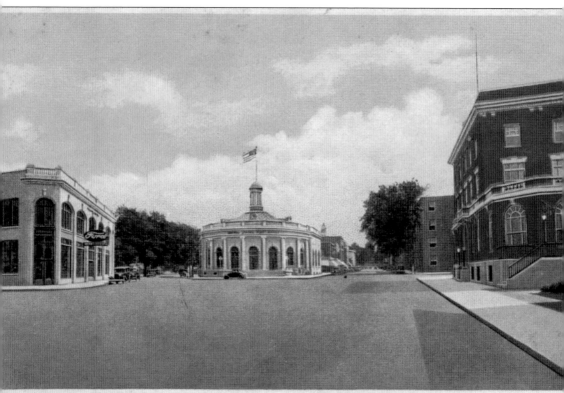

K-1003 U. S. POST OFFICE. SHOWING Y. M. C. A. AND MILLARD BUILDING. KINGSTON. N. Y.

Driving down Broadway from uptown to downtown, the heart of midtown made a favorable impression. The US Post Office signaled the entry to Kingston's civic center. The scene was drastically altered when the post office was demolished in 1969–1970 and a fast-food outlet put on the site. The lost building has become the rallying cry for preservation in Kingston. (Courtesy Edwin M. and Ruth Ford Collection.)

Three

DOWNTOWN
RONDOUT NATIONAL
HISTORIC DISTRICT

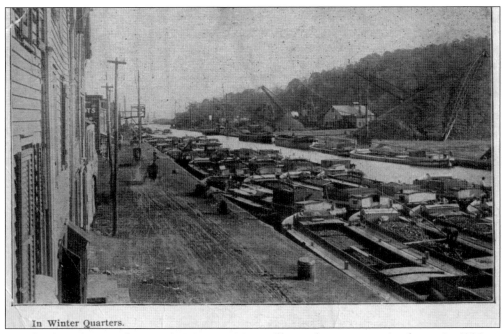

In Winter Quarters.

Farmland mushroomed into a thriving maritime village when construction began in 1825 on the Delaware & Hudson Canal. Both entrepreneurs and immigrants, mostly from Ireland and Germany, poured in hoping to ride the tide of prosperity promised by the canal and the allied industries it created in this microcosm of the Industrial Revolution. The Delaware & Hudson Canal was the brainchild of the Wurts brothers—Maurice, William, and John—of Philadelphia, and the venture became the first private million-dollar enterprise in the United States, with its stock selling out in one day. The canal transported coal 108 miles from Honesdale, Pennsylvania, to Rondout, where it was shipped to major cities along the eastern seaboard. (Courtesy Friends of Historic Kingston Archives.)

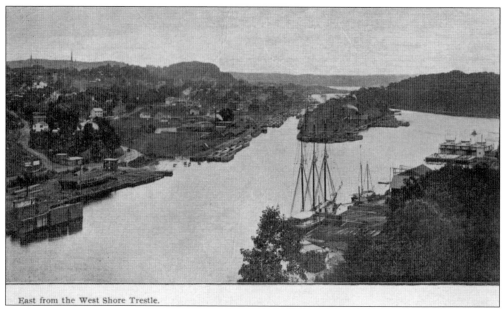

East from the West Shore Trestle.

A man-made island was built by the Delaware & Hudson Canal Company in the middle of the Rondout Creek to store huge piles of coal before it was loaded on to larger boats for shipment on the Hudson River. Designed by James McEntee, the canal company's local engineer, it was the first pile dock ever built in America. At its peak of prosperity in 1870, the canal carried three million tons of coal. (Courtesy Edwin M. and Ruth Ford Collection.)

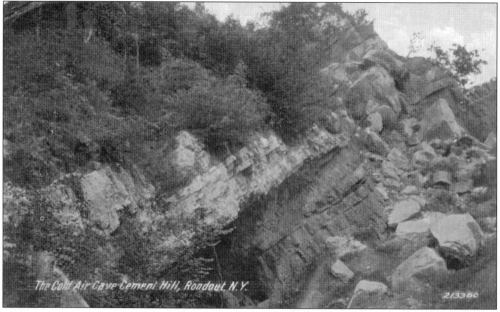

The Cold Air Cave Cement Hill, Rondout N.Y.

While digging the Delaware & Hudson Canal, workers discovered a vein of natural cement 14 to 20 feet thick in the limestone ridge that runs from Rosendale to Kingston. Called Rosendale cement, it hardened like stone in water and was used in the base of the Statue of Liberty, Brooklyn Bridge, Washington Monument, US Capitol Building, and Grand Central Terminal. Cement mining became a major local industry. (Courtesy Frank A. Almquist Collection.)

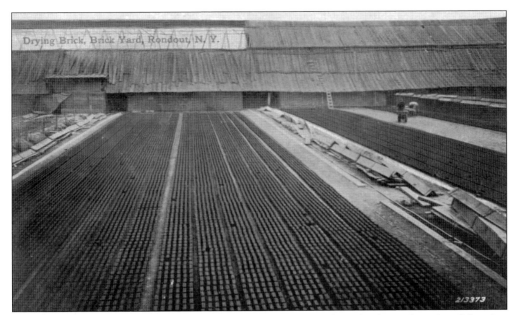

Along the Hudson River, in banks as high as 150 feet at Rondout, lay huge deposits of clay that spawned another major local industry, brick making. Before mechanization in the 1880s, each worker was supposed to turn out 1,000 bricks a day. After being molded, the bricks were laid out in large yards to dry. The industry died locally when the Hutton Brickyard closed in 1980. (Courtesy Frank A. Almquist Collection.)

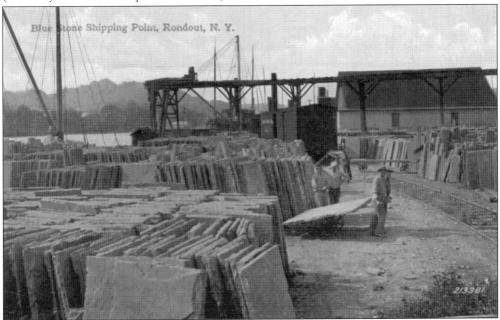

Wagonloads of bluestone, quarried from near Kingston, were hauled down to yards in Rondout, where the stones were sawed, rubbed and planed, then shipped. The Fitch Brothers, the largest exporters of bluestone in the world in 1850, built a bluestone office on the Rondout Creek that still stands. The sidewalks of New York are paved with Ulster County bluestone. (Courtesy Frank A. Almquist Collection.)

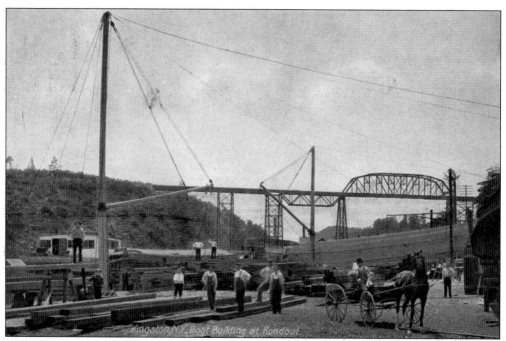

Boat building and repairing fast became a major industry in Rondout due to the Delaware & Hudson Canal. After the canal closed in 1898, many of the boatyards lining the Rondout Creek continued to prosper until the mid-20th century. Today, only one, Thomas J. Feeney Enterprises, remains. (Courtesy Frank A. Almquist Collection.)

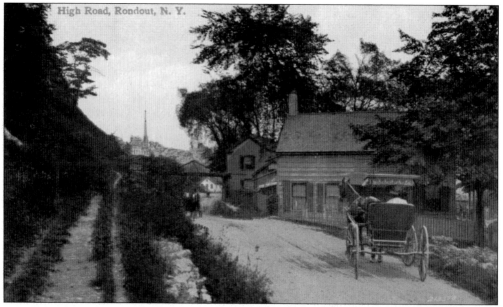

Many workers walked to their jobs in Rondout on the High Road, which began at the end of Yeomans Street in the Ponckhockie section of Kingston and passed along the property of the Newark Lime and Cement Company on its way down to the Strand. The Newark Lime and Cement Company, a major employer in Rondout, produced more than 1,000 barrels of cement daily. (Courtesy Frank A. Almquist Collection.)

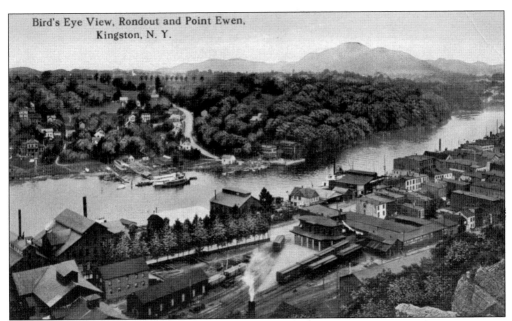

Bird's Eye View, Rondout and Point Ewen, Kingston, N. Y.

Starting with one boat, Thomas Cornell (1814–1890) built a shipping empire that dominated the Hudson River for more than a century. Two Cornell Steamboat Company buildings with raised roofs and clerestory windows—the boiler shop and repair shop—can be seen to the left. Boats could access the buildings directly from the Rondout Creek. Both buildings still stand and have been repurposed. (Courtesy Frank A. Almquist Collection.)

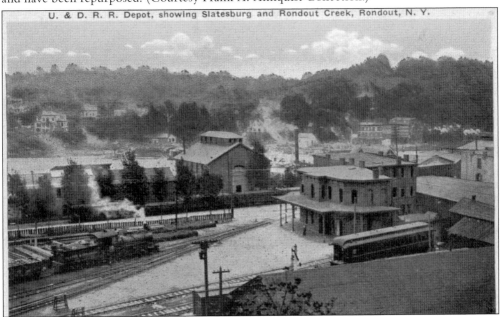

U. & D. R. R. Depot, showing Slatesburg and Rondout Creek, Rondout, N. Y.

In the 1870s, when Thomas Cornell foresaw rail transport replacing canals, he began to invest in railroads. The Ulster and Delaware (U&D) Railroad ran 108 miles from Rondout to Oneonta, carrying passengers to the Catskill Mountains, where Cornell also owned large resort hotels. The railroad also transported milk and fresh produce from dairy farms in the Catskills to New York City. The U&D's last run was on March 31, 1954. (Courtesy Frank A. Almquist Collection.)

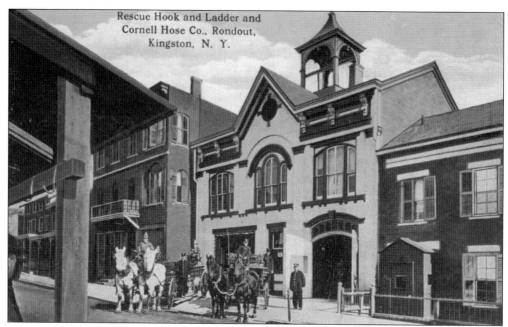

A great fire that swept through Rondout in 1849 prompted the founding of a fire department. In 1851, a building was erected to serve as both a firehouse and the village hall. The fire company was named the Cornell Hose Company to honor one of Rondout's most notable entrepreneurs, Thomas Cornell. The restored building now houses a flower shop on the ground floor and a private residence upstairs. (Courtesy Friends of Historic Kingston Archives, Herman Boyle Collection.)

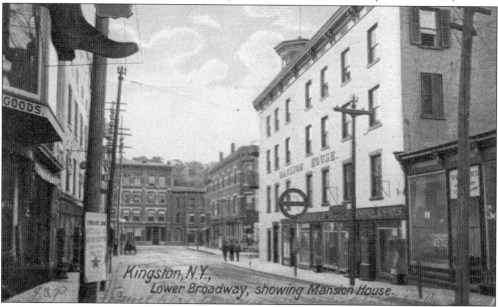

At the foot of Broadway, the Cornell Steamboat Office Building occupied the center of the Strand. Built around 1883, the handsome building was demolished in 1966 by urban renewal. The T.R. Gallo Park occupies the space. The Mansion House and Sampson Opera House, on the right, both survive and house restaurants and apartments. The high-buttoned shoe suspended on the left is meant to draw customers into Sol Appel's shoe store. (Courtesy Frank A. Almquist Collection.)

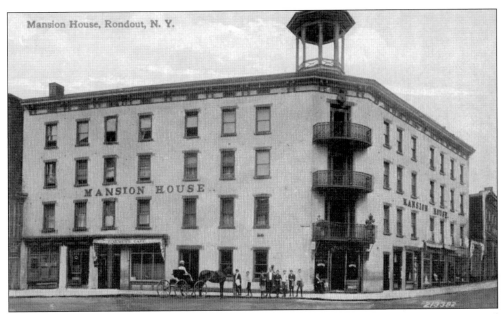

Mansion House, Rondout, N. Y.

James McEntee, the resident engineer for the Delaware & Hudson Canal Company, opened Rondout's first hotel, the Mansion House, in 1832 in a renovated house ideally located near the dock where passengers disembarked. In 1854, a new owner, entrepreneur George Von Beck, demolished it and built a large brick hotel boasting "100 sleeping compartments, elegantly furnished and gas-lit." The 1854 building has been converted to apartments, but the cupola no longer crowns the rooftop. (Courtesy Frank A. Almquist Collection.)

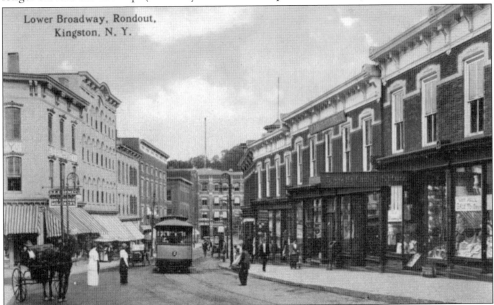

Lower Broadway, Rondout, Kingston, N. Y.

Many commercial storefronts built in the 1870s, when Rondout was at its peak of prosperity, had cast-iron piers manufactured by Rondout Iron Works, owned by John McEntee and John Dillon. Several on the west side of lower Broadway survived the onslaught of urban renewal, and the foundry's name can be seen molded into the bases of the piers. (Courtesy Frank A. Almquist Collection.)

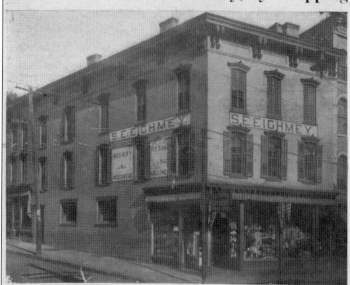

S.E. Eighmey's sent postcards to its customers with a handwritten message on the back: "We hope to see you very often during the fall season. Thanking you for all favors." The building at 26 Broadway was demolished by urban renewal. (Courtesy Friends of Historic Kingston Archives, Herman Boyle Collection.)

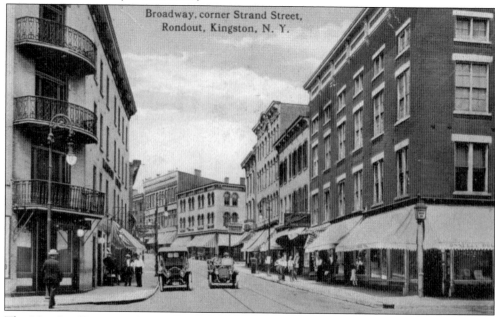

The Mansion House on the left is the lone survivor of the buildings shown above. The entire east side of Rondout was demolished during urban renewal in the late 1960s and lives now only in photographs. Many family businesses, such as Yallum's clothing and shoe store at 12 Broadway, were forced to relocate from Rondout to uptown Kingston. (Courtesy Frank A. Almquist Collection.)

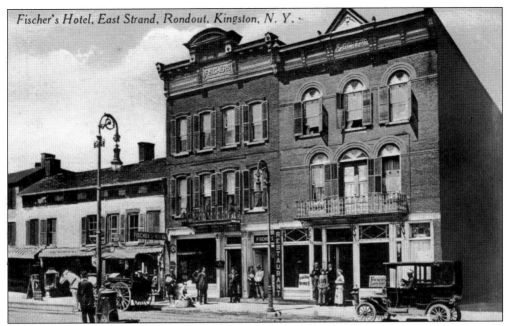

Fischer's Hotel occupied both three-story buildings, and its dining room advertised that it served wines. The cast-iron railings on the balconies adorned many Rondout buildings and were manufactured right in the village by Rondout Iron Works, later called McEntee and Dillon. (Courtesy Frank A. Almquist Collection.)

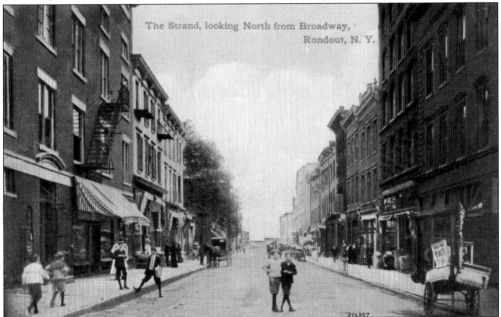

The entire commercial strip on East Strand Street was obliterated by urban renewal in the late 1960s, along with adjacent Ferry Street. A wide thoroughfare named Rondout Landing replaced the two streets. The Hudson River Maritime Museum, Trolley Museum, Hudson River Cruises, an apartment complex, and several restaurants populate the street. (Courtesy Frank A. Almquist Collection.)

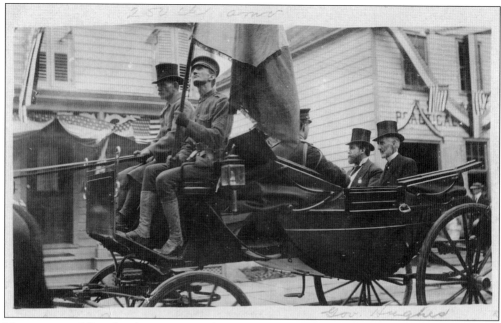

No one proved Rondout's promise as a land of opportunity more than Samuel D. Coykendall (right), who rose from the position of a retail clerk to the wealthiest and most powerful man in Ulster County. The son-in-law of Thomas Cornell, Coykendall inherited his empire and then expanded it. Here, he is riding with Gov. Charles Evans Hughes, a friend, during Kingston's 250th-anniversary celebration in 1908. (Courtesy Friends of Historic Kingston Archives, Herman Boyle Collection.)

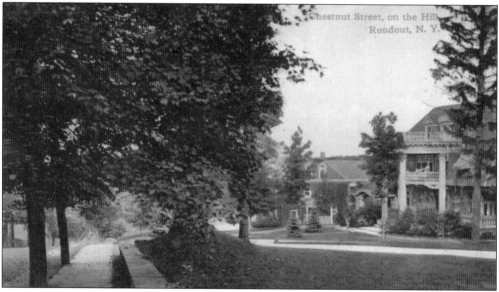

Beginning in 1850, noted Rondout entrepreneurs began to build large homes in a variety of architectural styles on West Chestnut Street, now the heart of the Chestnut Street Historic District. The Colonial Revival–style home of George Washburn, a prominent brick manufacturer, featured an impressive colonnaded portico. Fire destroyed the house in 1957. (Courtesy Frank A. Almquist Collection.)

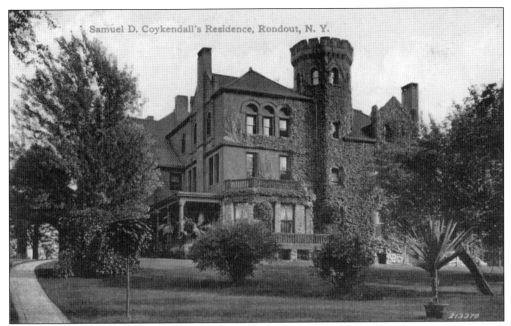

Samuel Coykendall built a mansion with a crenellated tower designed by Calvert Vaux on the West Chestnut Street property where the home and studio of Hudson River School artist Jervis McEntee once stood. The tower commanded sweeping views of the Hudson River and Catskill Mountains. After Coykendall's death in 1913, the house sat vacant until it finally met the fate of the wrecking ball in 1949. (Courtesy Frank A. Almquist Collection.)

James McEntee owned most of the land on West Chestnut Street, a ridge with steep banks on both sides. The street that lies below the east side was named McEntee Street after the family whose members played such an influential role in early Rondout. Hauck's Brewery is seen in the distance. (Courtesy Frank A. Almquist Collection.)

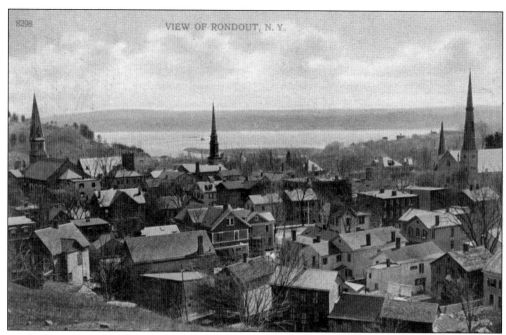

Spires rising from churches pierce Rondout's skyline. Each nationality and religious denomination that immigrated to Rondout erected its own house of worship. Many congregations held services in homes before their church buildings were erected. (Courtesy Frank A. Almquist Collection.)

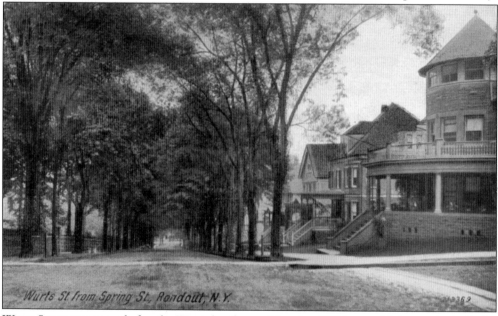

Wurts Street was named after the Wurts brothers—Maurice, William and John—who built the Delaware & Hudson Canal, but it might more aptly be called Church Street because of the many churches that process up its hill. The hollow space beneath Wurts Street's arching tree limbs looks not unlike a church nave. The bluestone house on the right was built around 1896 by bluestone dealer James J. Sweeney and served as a living advertisement for his business. (Courtesy Frank A. Almquist Collection.)

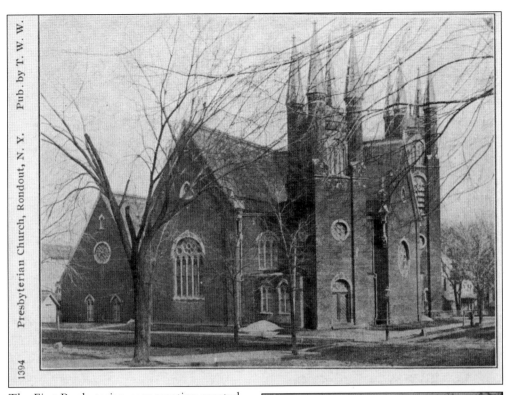

Pub. by T. W. W.

Presbyterian Church, Rondout, N. Y.

1394

The First Presbyterian congregation erected Rondout's first church building in 1834 at 50 Abeel Street, the later site of Temple Emanuel. A founding member was Maurice Wurts, the canal builder. In 1873, a much larger church was built opposite on the corner of Wurts Street and became known as the "Ten Steeple Church." Services were discontinued in 1944, and the church was later demolished. A gas station, now defunct, later occupied the site. (Courtesy Friends of Historic Kingston Archives, Herman Boyle Collection.)

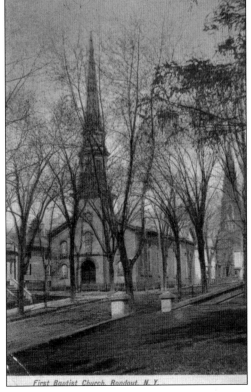

The land on which the First Baptist Church was built in 1861 on the corner of Wurts and Spring Streets was donated by Rondout entrepreneur and benefactor Thomas Cornell, who was a deacon of the congregation. Although still standing, the building is in private hands. The limestone pillars mark the entryway to Cornell's house, which stood across the street. (Courtesy Frank A. Almquist Collection.)

First Baptist Church, Rondout, N. Y.

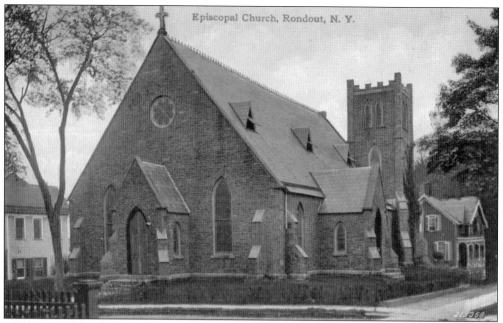

The Gothic-style bluestone church at 72 Wurts Street was built in 1861 as an Episcopal church, but the congregation was dissolved in 1924. From 1926 to 1966, it was the home of Congregation Ahavath Israel, then it was sold to St. Mark's African Methodist Episcopal Church, which still worships there. (Courtesy Friends of Historic Kingston Archives, Herman Boyle Collection.)

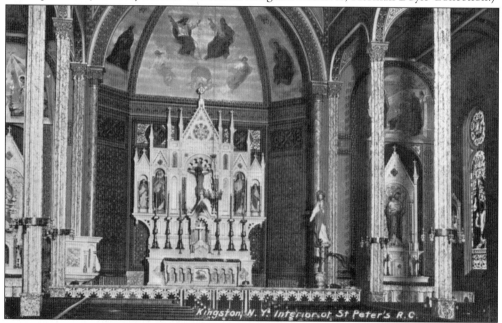

The parish of St. Peter's was organized in 1850 for German-speaking Catholics in Rondout, and two decades later, Henry Engelbert, a German-American architect from New York, was hired to design a church. Built at 91 Wurts Street between 1871 and 1873, the church is designed in the German medieval style. Today, St. Peter's ministry is mostly to the local Spanish population. (Courtesy Friends of Historic Kingston Archives, Herman Boyle Collection.)

German-speaking Lutherans formed a congregation in 1842 and erected a church building at 72 Spring Street, near Wurts Street, between 1873 and 1875. They also employed the designer of St. Peter's Church, Henry Engelbert, as their architect, and the church exterior has similar German medieval details but with a Gothic spire. In 1875, a busy Engelbert was also engaged in the design of the Sampson Opera House at 1 Broadway on the Strand. (Courtesy Frank A. Almquist Collection.)

Joined to the rear of the church, the Trinity Lutheran parsonage faces Hone Street. The porches have been removed, but the remainder of the exterior is intact. (Courtesy Friends of Historic Kingston Archives, Herman Boyle Collection.)

PARSONAGE.
Souvenir of the Re-dedication of the Renovated Spring St. German Lutheran Church, November 5th, 1905.

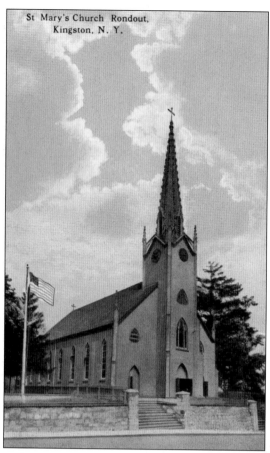

St Mary's Church Rondout, Kingston. N. Y.

The second religious congregation formed in Rondout, St. Mary's was organized in 1835 mainly for Irish immigrants working on the Delaware & Hudson Canal and their families. In 1848, a large brick Gothic Revival–style church crowning the hilltop at 162 Broadway replaced a wooden building used for services since 1838. (Courtesy Friends of Historic Kingston Archives, Herman Boyle Collection.)

A different exterior emerged when St. Mary's Church was altered between 1922 and 1924. The ornate spire and pinnacles were removed and the building was wrapped in brick with cast-stone trim, giving it a more Gothic appearance. A rectory and convent in the same style were built at the same time. (Courtesy Frank A. Almquist Collection.)

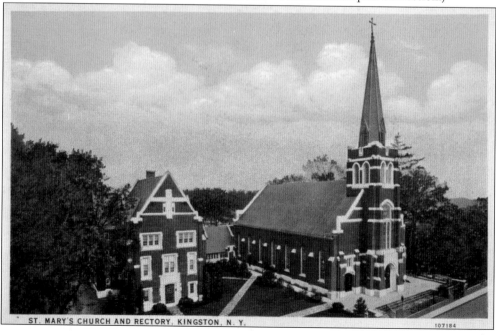

ST. MARY'S CHURCH AND RECTORY, KINGSTON, N. Y.

107184

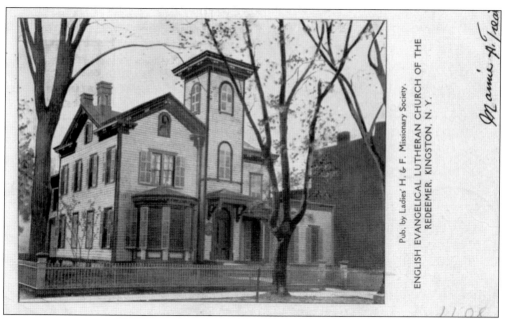

In 1896, a new generation of Germans asked the pastor at the Trinity Lutheran Church to conduct services and religious instruction in English. When he refused, they formed the English Evangelical Redeemer Lutheran Church. Services were held in the Liscomb Opera House (Orpheum Theater, 103 Broadway) until the congregation bought and remodeled a large house at 104 Wurts Street. (Courtesy Frank A. Almquist Collection.)

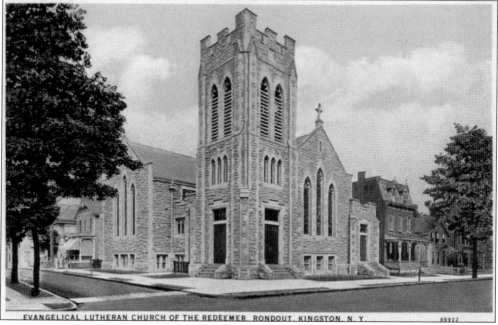

EVANGELICAL LUTHERAN CHURCH OF THE REDEEMER, RONDOUT, KINGSTON, N. Y.

Between 1911 and 1913, on the site of the original church and parsonage property, a Gothic Revival–style church was built of St. Lawrence marble with Indiana limestone trim. Choosing an architectural style different from the Trinity Lutheran Church was the congregation's final declaration of independence from its mother church. (Courtesy Frank A. Almquist Collection.)

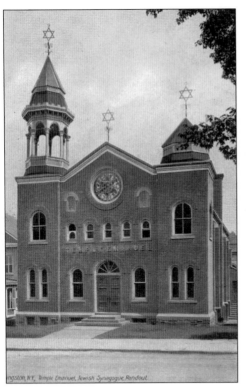

Kingston, N.Y., Temple Emanuel, Jewish Synagogue, Rondout.

Temple Emanuel was built in 1892–1893 at 50 Abeel Street, the site of the original First Presbyterian Church, but the congregation had been organized in 1854 by German Jews. The three Stars of David on the roofline and the minaret on the left have been removed, but two tablets of the Law embedded in the wall on either side of the center window remain. The original large stained-glass window is now at the synagogue on Albany Avenue, where the congregation moved in 1958. The building has been used for commercial purposes since. (Courtesy Friends of Historic Kingston Archives, Herman Boyle Collection.)

The Immanuel Evangelical Lutheran Church, at 22 Livingston Street, was built in 1870 for yet another German-speaking congregation in Rondout. The church operated an elementary school in the building on the right until the mid-20th century. (Courtesy Friends of Historic Kingston Archives, Herman Boyle Collection.)

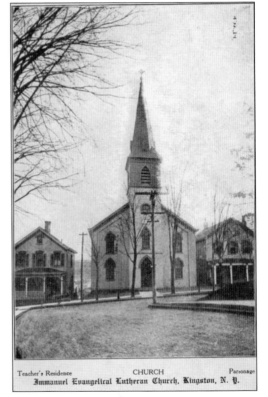

Teacher's Residence CHURCH Parsonage

Immanuel Evangelical Lutheran Church, Kingston, N. Y.

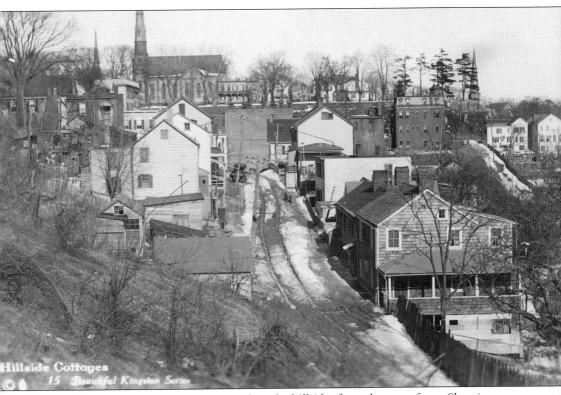

Hillside Cottages
15 Beautiful Kingston Series

As Rondout developed, its populace moved up the hillsides from the waterfront. Shanties were replaced by cottages, some built as workers' housing by the Delaware & Hudson Canal Company. This post–1875 view is from German Street looking east. The Trinity Lutheran Church can be seen on the crest of the hill, with the Hoffman Brewery directly below. The postcard is part of a series of art photographs of Kingston by L.E. Jones of Woodstock, New York. (Courtesy Edwin M. and Ruth Ford Collection.)

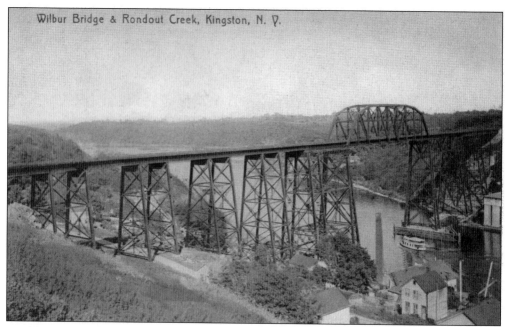

In 1904, the original bridge constructed in 1882 by the West Shore Railroad over the Rondout Creek at Wilbur was rebuilt to carry heavier trains. The bridge made it possible for the West Shore Railroad to run a continuous route from Buffalo to Weehawken, New Jersey, from where passengers were ferried across the Hudson River to New York City. (Courtesy Frank A. Almquist Collection.)

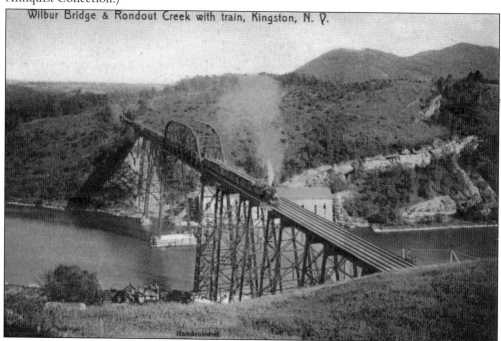

The old Wilbur railroad bridge is still in use today. In 1959, passenger service was discontinued on the line, then owned by the New York Central Railroad, but many CSX freight trains cross the bridge daily. (Courtesy Frank A. Almquist Collection.)

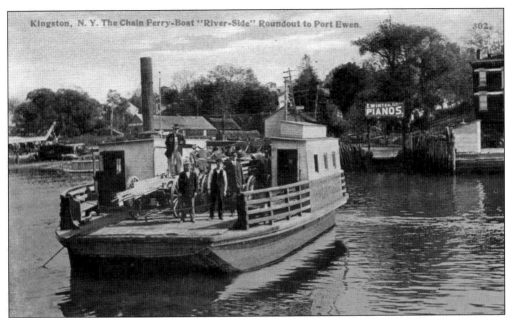

In 1870, the *Riverside*, commonly called the *Skillypot* from the Dutch word meaning "turtle," began service between Rondout and Sleightsburg across the Rondout Creek. The engine was propelled by a chain fastened to each shore. The ferry could carry four teams of horses with vehicles and had separate cabins for ladies and men. (Courtesy Friends of Historic Kingston Archives, Herman Boyle Collection.)

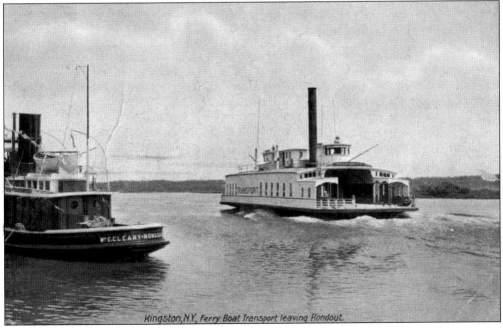

Kingston, N.Y. Ferry Boat Transport leaving Rondout.

In August 1881, the *Transport*, a former rail transfer boat and side-wheeler, began ferry service from Rondout across the Hudson River to Rhinecliff. The men's and ladies' separate cabins had chandeliers and seats made of black walnut and basswood. The *Transport* had the strongest paddle wheels on the Hudson. (Courtesy Edwin M. and Ruth Ford Collection.)

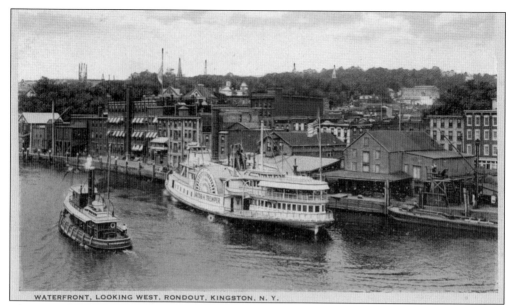

WATERFRONT, LOOKING WEST, RONDOUT, KINGSTON, N. Y.

The port at Rondout, one of only two deepwater ports on the Hudson River, had been busy since the days when Dutch sloops came and went with passengers and goods. The port and Rondout Creek burst into activity with the opening of the Delaware & Hudson Canal in 1828. The *Jacob Tremper*, one of Rondout's noted side-wheelers, is seen at the dock. (Courtesy Frank A. Almquist Collection.)

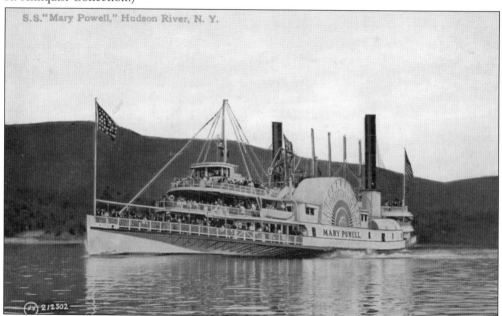

S.S. "Mary Powell," Hudson River, N. Y.

The *Mary Powell*, the most legendary steamboat on the Hudson River and one of the most graceful in appearance, made daily runs, except for Sunday, between Rondout and New York for 59 seasons. For a time, it was one of the fastest boats on the Hudson, completing the round-trip in approximately 14 hours. Distinguished passengers included Walt Whitman, Oscar Wilde, and Pres. Ulysses Grant. It made its final run on September 5, 1917, and, to the dismay of many, was sold for scrap. (Courtesy Friends of Historic Kingston Archives, Herman Boyle Collection.)

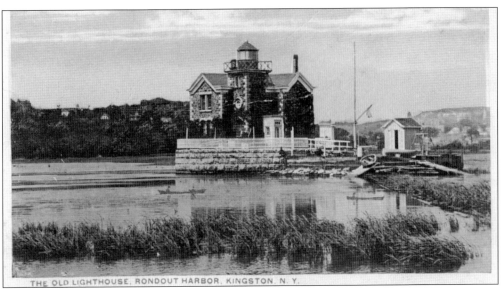

THE OLD LIGHTHOUSE, RONDOUT HARBOR, KINGSTON, N. Y.

Poised at the mouth of the Rondout Creek where it meets the Hudson River, the first Rondout Lighthouse was built of wood in 1837 by James McEntee, the resident engineer for the Delaware & Hudson Canal Company. It quickly aged and was replaced in 1867 by one built of bluestone. From 1857 to 1907, the lighthouse keeper was Catherine Murdock, who took over her husband's post after he drowned in the river. Noted for being unflappable, Murdock was unfazed when she was woken up by a raging storm and found the prow of a ship poking through a downstairs window. (Courtesy Frank A. Almquist Collection.)

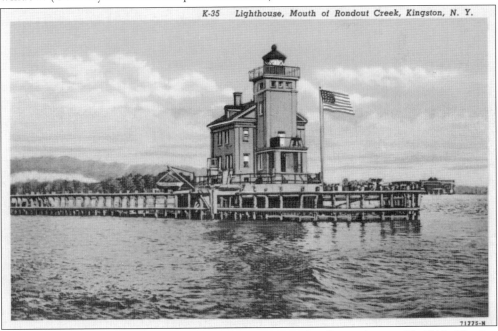

K-35 Lighthouse, Mouth of Rondout Creek, Kingston, N. Y.

Built of a light-toned brick, the current lighthouse was first lit on August 15, 1915. The last keeper left in 1954, when the light was automated. The Hudson River Maritime Museum leases the lighthouse from the City of Kingston and offers boat tours out there. Together, the museum and city are working to restore the structure. (Courtesy Frank A. Almquist Collection.)

On the drawing board since 1914 but delayed by World War I, construction of the Rondout Creek Bridge finally began in 1919. The cornerstone of Ulster County bluestone was laid by Gov. Alfred E. Smith on September 18, 1920. (Courtesy Friends of Historic Kingston Archives, Herman Boyle Collection.)

The original plans for a steel bridge with concrete piers were scrapped when it was discovered that rock below the creek bed would not allow the piers to be implanted. A suspension bridge was planned instead. (Courtesy Friends of Historic Kingston Archives, Herman Boyle Collection.)

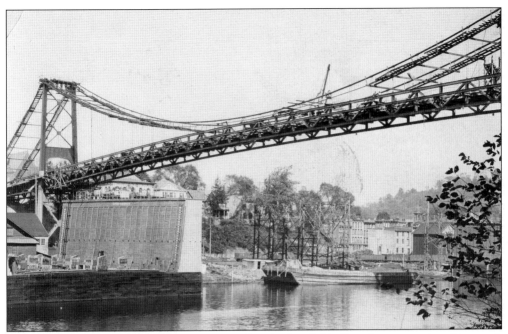

Near the end of construction, cracks appeared in the bands binding the two main cables, each composed of 1,974 wires. People were amazed when they were repaired by a woman, Catherine Nelson, an electrical welder from New Jersey, and crowds gathered to watch. (Courtesy Friends of Historic Kingston Archives, Herman Boyle Collection.)

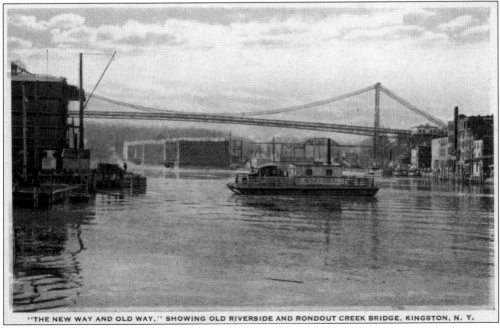

"THE NEW WAY AND OLD WAY," SHOWING OLD RIVERSIDE AND RONDOUT CREEK BRIDGE, KINGSTON, N. Y.

The new Rondout Creek Bridge, which one newspaper hailed as "the gateway to the West," put the old chain ferry, the *Skillypot*, seen below the bridge, out of business. (Courtesy Margaret O'Reilly Paulson Collection.)

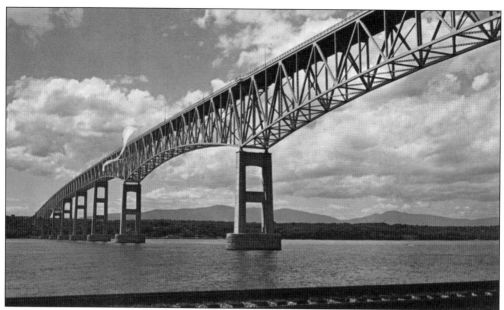

The Kingston–Rhinecliff ferry was retired when the Kingston–Rhinecliff Bridge opened on February 2, 1957. Driving west on the 7,793-foot span offers a stunning vista of the Catskill Mountain ridgeline. The bridge was renamed the George Clinton Bridge in 2000 in honor of New York State's first and longest serving governor, who is buried in the Old Dutch Churchyard in Kingston. (Courtesy Friends of Historic Kingston Archives, Herman Boyle Collection.)

Seven c. 1870 Italianate-style buildings standing on the West Strand are among the few survivors of urban renewal of the late 1960s that attest to the thriving maritime village that once existed in Rondout. Facing the Rondout Creek, this handsome row of buildings houses a variety of businesses that draw people to Kingston's revitalized waterfront area. (Courtesy Edwin M. and Ruth Ford Collection.)

Four

KINGSTON
CARING FOR ITS CITIZENS

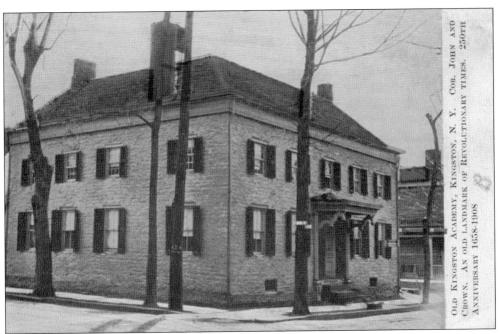

OLD KINGSTON ACADEMY, KINGSTON, N. Y. COR. JOHN AND CROWN. AN OLD LANDMARK OF REVOLUTIONARY TIMES. 250TH ANNIVERSARY 1658-1908

Founded in 1774, Kingston Academy became the focal point of higher education for New York and drew students statewide. Distinguished alumni include the artist John Vanderlyn, Gov. Dewitt Clinton, and Edward Livingston, secretary of state under Andrew Jackson. The Kingston Academy occupied this structure on the corner of Crown and John Streets until 1830, when a new school building was erected on Clinton Avenue and Maiden Lane. The original 1774 building still stands, but its architecture has been compromised by commercial use. (Courtesy Frank A. Almquist Collection.)

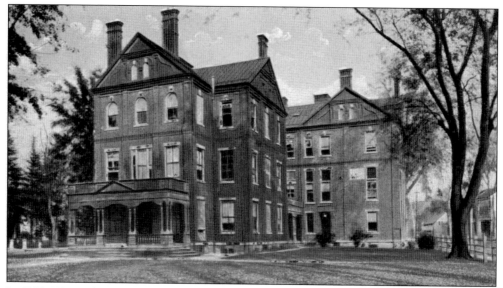

In 1830, Kingston Academy moved to a larger school built on a triangular piece of land bordering Maiden Lane and Albany and Clinton Avenues. It occupied this site until 1915, when its heir, Kingston High School, opened at 399 Broadway. The school building was demolished in 1916, and the site became a city park known as the Academy Green. (Courtesy Friends of Historic Kingston Archives, Herman Boyle Collection.)

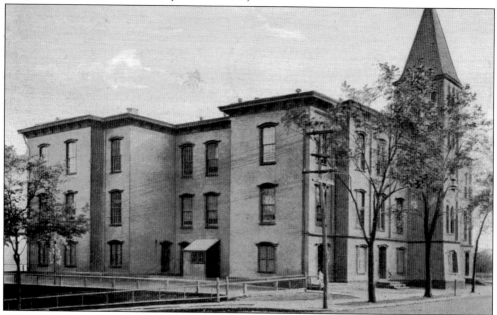

In 1870, the village of Rondout built a primary and secondary school that rivaled Kingston Academy in academic excellence, and by the 1890s, it outstripped Kingston Academy in population, having between 800 and 900 students. Its facilities included a science laboratory and library with 1,500 volumes. When Kingston High School opened in 1915, the building became School No. 2 in the Kingston City School System, and in the 1960s, it became the first campus of Ulster County Community College. (Courtesy Friends of Historic Kingston Archives, Herman Boyle Collection.)

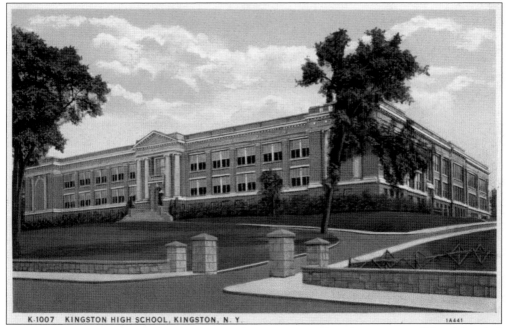

When the new Kingston High School opened in 1915 at 399 Broadway, it consolidated the rival student populations of Kingston Academy and Ulster Academy under one roof. In 2012, it still serves as the single high school for the Kingston Consolidated School System. (Courtesy Friends of Historic Kingston Archives, Herman Boyle Collection.)

In 1926, St. Ursula's Academy was established on Grove Street on the site of the Home of the Holy Child, an orphanage. The high school was located in the former home of Walter B. Crane, designed around 1862 or 1863 by the noted architect Calvert Vaux. The building was demolished in the 1960s, and the campus is now occupied by the Children's Home of Kingston. (Courtesy Edwin M. and Ruth Ford Collection.)

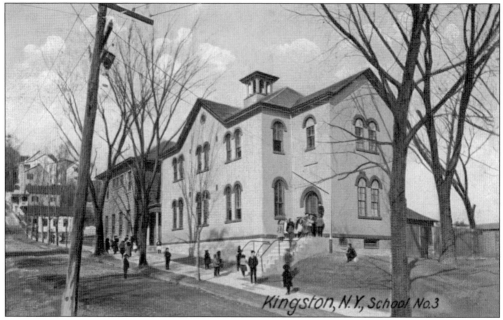

Each neighborhood in Kingston had its own public elementary school within easy walking distance for its young pupils. School No. 3 was built around 1896 at 114 Chambers Street to serve students living on the east side of Broadway in Rondout. The school was demolished in 1965 by the Kingston Urban Renewal Agency, and the street was also obliterated from the map. (Courtesy Frank A. Almquist Collection.)

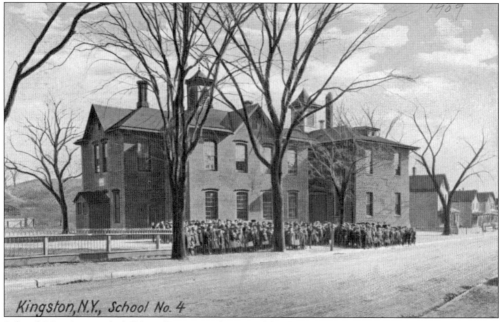

School No. 4 served children living in the Ponckhockie section of Kingston. Many of their parents were employed by the nearby Newark Lime and Cement Company, which supplied the cement at low cost for the building. The original 1867 building at 229 Delaware Avenue still stands. (Courtesy Friends of Historic Kingston Archives, Herman Boyle Collection.)

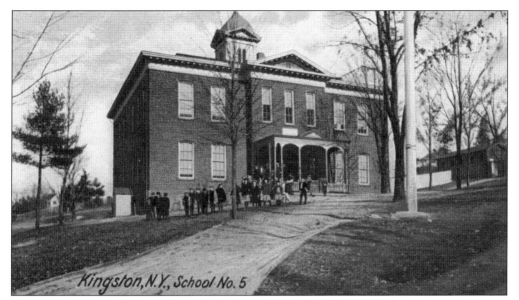

Kingston, N.Y., School No. 5

School No. 5 was built in midtown about 1890 at 21 Wynkoop Place, formerly called Chapel Lane, most likely because the Reformed Comforter Church is directly opposite. The original building has been added to several times, and its name changed to the Meagher School after Col. Frank L. Meagher, a beloved, longtime principal. The Kingston City School System closed the school at the end of the 2012 school year. (Courtesy Friends of Historic Kingston Archives, Herman Boyle Collection.)

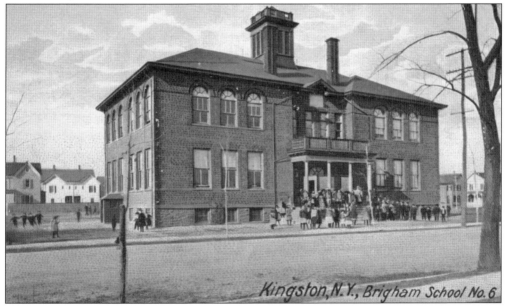

Kingston, N.Y., Brigham School No. 6

School No. 6 was built in the Albany Avenue neighborhood at 107 O'Neil Street between 1899 and 1901. The architect, Arthur Curtis Longyear, also designed Kingston High School. It was named the Brigham School after Elisha M. Brigham, a prominent figure in the local cement industry and president of the board of education for many years. The building was demolished in 2000, and an affordable housing complex was constructed on the site. (Courtesy Friends of Historic Kingston, Herman Boyle Collection.)

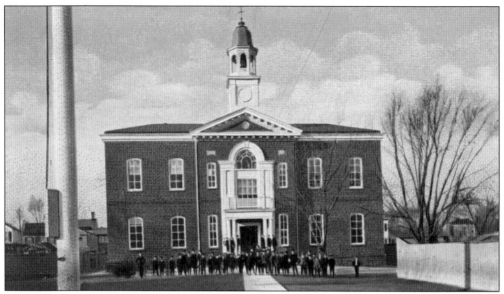

Originally School No. 11, School No. 7 was built around 1900 at 61 Crown Street in the uptown business district. One year later, following a calamitous fire, only the brick walls were left standing, but the school was rebuilt. In the 1970s, the school was closed and the student population transferred to the George Washington School on Wall Street. The building was converted to office space and serves as the administrative headquarters for the Kingston Consolidated School System. (Courtesy Friends of Historic Kingston Archives, Herman Boyle Collection.)

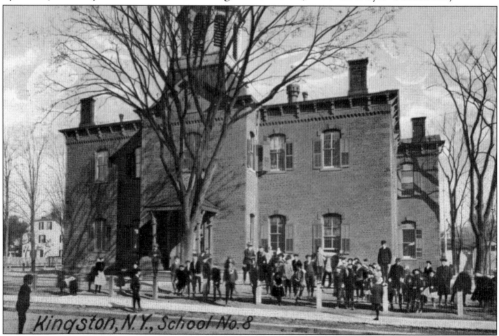

School No. 8, at 55 Franklin Street in midtown, was started a few years earlier than the 1878 Italianate-style building still standing on the site. The school closed its doors in the 1970s, and students were absorbed into the nearby George Washington School. The doors reopened in 1978 as the new home of the Kingston Library. (Courtesy Frank A. Almquist Collection.)

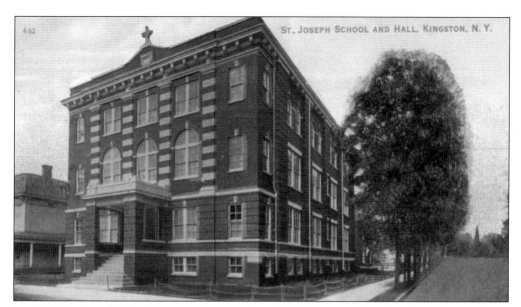

In 1913, St. Joseph's Parish opened a new school building near the church on the northeast corner of Wall and Pearl Streets. Designed by Arthur C. Longyear, the architect of Kingston High School, the spacious three-story building replaced the school's home since 1905 in the former Alton B. Parker residence at 1 Pearl Street. The school was started in 1868 in a wooden building no longer standing on the southwest corner of Fair and Franklin Streets. (Courtesy Frank A. Almquist Collection.)

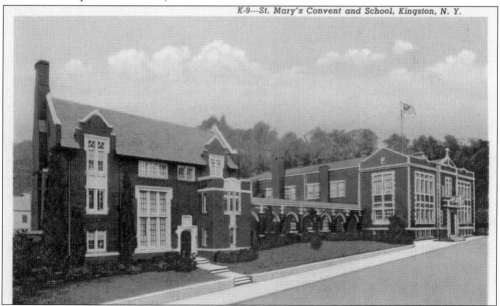

K-9—St. Mary's Convent and School, Kingston, N. Y.

St. Mary's Parish also opened a new school building in 1913 at 159 Broadway, and it too was designed by Arthur C. Longyear, the architect of St. Joseph's School. The convent was added to the parish complex in 1924. The Gothic style of both buildings harmonized with the church across the street. When neighboring St. Peter's School closed its doors in the 1990s, its student population combined with St. Mary's, and the school was renamed Kingston Catholic. (Courtesy Dr. William B. Rhoads Collection.)

101

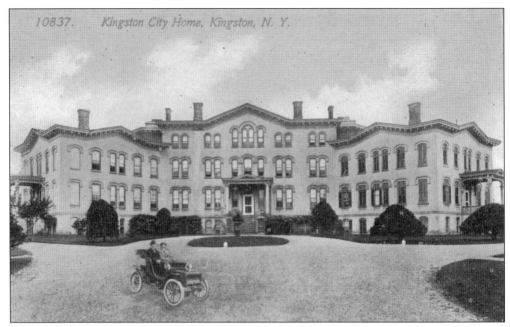

The Kingston City Alms House was the first building erected by city government after Rondout and Kingston united in 1872. Designed between 1872 and 1874 by J.A. Wood, the institution was intended to care for the chronically poor. Remodeled in 1954, it became the Ulster County Chronic Infirmary. The Ulster County Health Department is currently quartered there. (Courtesy Friends of Historic Kingston Archives, Herman Boyle Collection.)

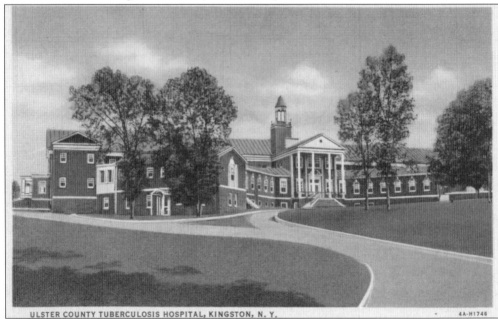

ULSTER COUNTY TUBERCULOSIS HOSPITAL, KINGSTON, N. Y. 4A-H1746

The Ulster County Tuberculosis Hospital was built on the crest of Golden Hill in 1931 in the Colonial Revival style favored by Kingston architects Myron Teller, Harry Halverson, and Charles Keefe. The main building was demolished during the 2000s, leaving only the nurses' residence, which is not shown. (Courtesy Edwin M. and Ruth Ford Collection.)

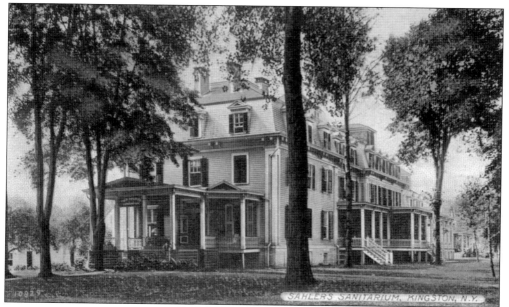

From 1896 until his death in 1917, Dr. Charles O. Sahler operated a sanitarium for people with nervous and mental afflictions. His commonly used method of treatment—hypnosis—was the subject of controversy. One newspaper reported that local citizens were "apprehensive because patients wander about and mix in daily life." The sanitarium at 61 Wall Street could accommodate up to 150 patients. (Courtesy Friends of Historic Kingston Archives, Herman Boyle Collection.)

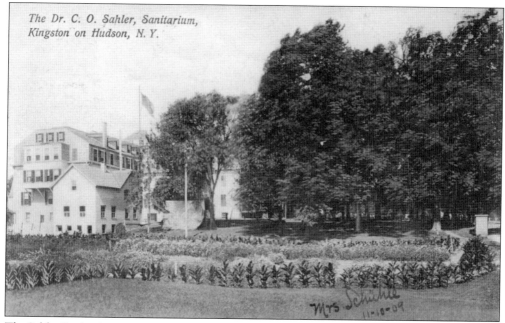

The Sahler Sanitarium property stretched from Washington Avenue to Wall Street. The sanitarium grew its own vegetables for the residents, and flower gardens graced the grounds. The site, bordered by a limestone wall on the Wall Street side, is now occupied by the George Washington Elementary School. (Courtesy Frank A. Almquist Collection.)

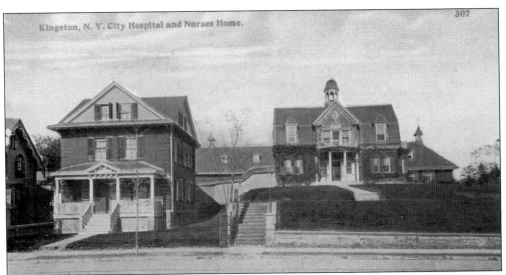

Kingston, N. Y. City Hospital and Nurses Home.

Kingston Hospital opened on November 27, 1894, in a wooden two-story building at 396 Broadway. A newly formed group, the Ladies' Hospital Aid Society, which became the Hospital Auxiliary Board, was responsible for raising a large portion of the needed funds. The nurses' home on the left was donated by Mary Augusta Coykendall. In its first two years, the hospital treated 256 patients, most of them for free. (Courtesy Friends of Historic Kingston Archives, Herman Boyle Collection.)

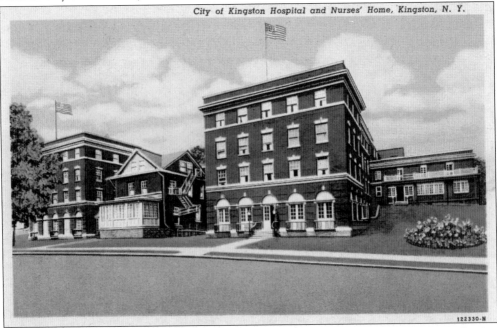

City of Kingston Hospital and Nurses' Home, Kingston, N. Y.

On February 20, 1926, fire destroyed the main portion of the hospital, where one woman having surgery was still under the influence of ether. There were 56 patients in the hospital at the time, but no lives were lost. An ambitious building plan resulted in the hospital being able to reopen just one year later in a much larger facility with a new residence for student nurses, although the original survived. Expansions in the 1950s and 1960s have absorbed the original hospital. (Courtesy Frank A. Almquist Collection.)

Benedictine Hospital opened in 1901 in a small house on West Chestnut Street with seven beds. Staffed by four sisters from the Benedictine Order in New Jersey, it was called Our Lady of Victory Sanitarium and Training School for Nurses and Domestics. In 1906, a 36-bed hospital building was opened at 105 Mary's Avenue. (Courtesy Edwin M. and Ruth Ford Collection.)

Additions to the original building, such as the Spellman Pavilion shown above, increased the Benedictine Hospital's capacity to 150 acute-care beds. The Benedictine is also an accredited Community Cancer Hospital. (Courtesy Frank A. Almquist Collection.)

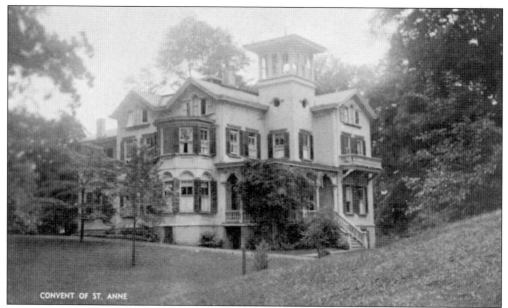

CONVENT OF ST. ANNE

The Convent of St. Anne was founded as an orphanage around 1926 at 287 Broadway by the Episcopal Order of St. Anne but extended its mission to serve young and elderly women who needed custodial care. The convent bells could be heard throughout the neighborhood tolling the Angelus three times a day. The sisters grew their own vegetables in a large garden behind the house. They left the area in the 1970s, and the building was demolished to build Yosman Tower, a senior housing complex. (Courtesy Frank A. Almquist Collection.)

THE ANGEL HOUSE

Angel House was a small brick building at the rear of the St. Anne Convent property where the residents were housed. It was demolished when the convent was razed to build the Yosman Tower complex. (Courtesy Frank A. Almquist Collection.)

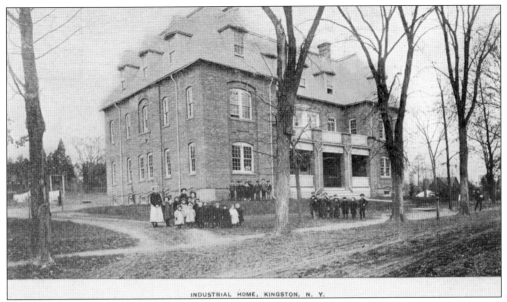

INDUSTRIAL HOME, KINGSTON, N. Y.

The Industrial Home of Kingston for Orphan Children was founded in 1876 by a prominent Kingston philanthropist, Mary Isabella Forsyth (1841–1914). Permanent housing for the institution was built in 1903 at 77 East Chester Street. The harsh-sounding word "industrial" was deleted from its name decades ago. Now known as the Children's Home, it occupies the former campus of the Academy of St. Ursula at 26 Grove Street. Its original West Chester Street home is occupied by the Morning Star Christian Fellowship, which operates the Good Shepherd School there. (Courtesy Frank A. Almquist Collection.)

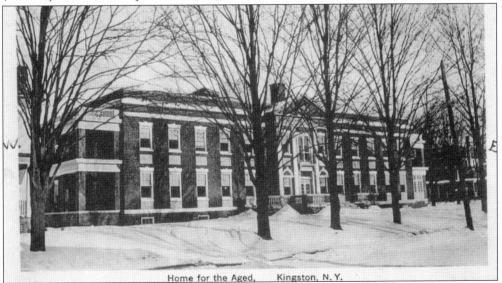

Home for the Aged, Kingston, N.Y.

The Ulster County Home for the Aged was founded by a group of Kingston citizens in 1919 on Green Street to care for elderly, though not indigent, women. In 1929, a portion of the Sahler Sanitarium property on Washington Avenue was purchased and the current facility built. In 1974, it was renamed the Hudson Valley Senior Residence, and in 1999, it was enlarged to 39 private rooms. The home offers assisted living care for both men and women. (Courtesy Frank A. Almquist Collection.)

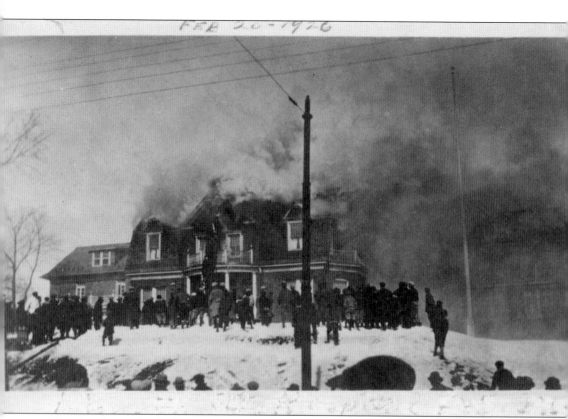

The Pennington Studio in uptown Kingston saw an opportunity for advertising its photographic expertise when a fire occurred at the original Kingston Hospital on February 20, 1926. The back of the card gives a capsule of the event and warns people to get a good photograph of their house or portrait of a loved one in case a fire or death should occur. Ending on a cheery note, it says, "Now is the time to make an appointment for the holidays." (Courtesy Friends of Historic Kingston Archives, Herman Boyle Collection.)

Five

KINGSTON
AT PLAY

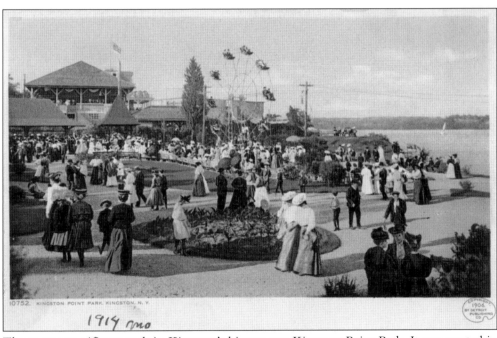

10752. KINGSTON POINT PARK, KINGSTON, N.Y.

1919 mo

The most magnificent park in Kingston's history was Kingston Point Park. It was created in 1897 by Samuel D. Coykendall, who rose from a store clerk to a transportation mogul with an empire that included trains, trolleys, boats, and a canal. From swampland, Coykendall developed an elegantly landscaped amusement park that drew visitors from throughout the Hudson Valley. A highlight of the park was a new attraction called the Ferris wheel, named after its inventor, who introduced it at Chicago's Columbian Exposition in 1893. Other amusements included a penny arcade, casino, shooting gallery, 900-seat theater, bandstand, dance pavilion, and a sandy beach. Young men could take their favorite girl for a ride in a rented rowboat or canoe on a man-made lagoon. (Courtesy Frank A. Almquist Collection.)

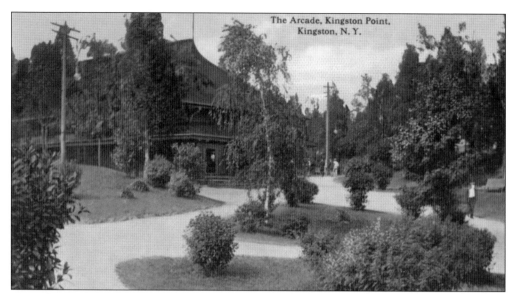

The Arcade, Kingston Point,
Kingston, N. Y.

Downing Vaux, son of Calvert Vaux, the codesigner of Central Park, was hired to landscape Kingston Point Park. He designed the park in the picturesque American Romantic style, with brick paths winding up and down tree-shaded knolls and through lush gardens. The paths were given pastoral names such as Briarwood, Mulberry, Piney Ridge Path, and Shadow Walk to Shadow Bay. (Courtesy Frank A. Almquist Collection.)

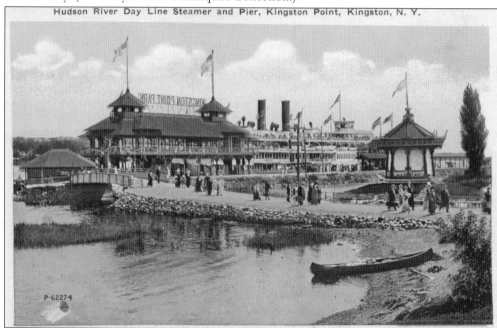

Hudson River Day Line Steamer and Pier, Kingston Point, Kingston, N. Y.

Kingston Point Park, with its many attractions, replaced Rhinecliff across the river as the landing dock for the Hudson River Day Line. Every day, the large boats left thousands of visitors at the park. Many caught trains there and continued up to resorts in the Catskill Mountains riding on Coykendall's Ulster & Delaware Railroad, which left from a station right next to the pavilion. Boosting his other business ventures was one of Coykendall's motives for creating the park. (Courtesy Margaret O'Reilly Paulson Collection.)

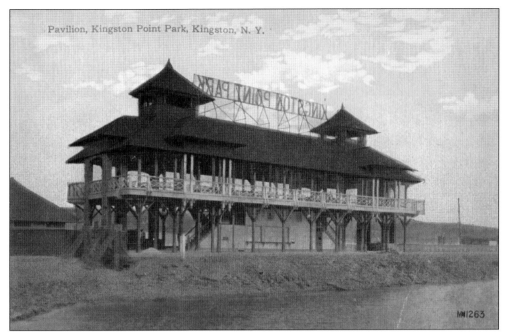

The park boldly announced itself to boat passengers in tall letters stretched between twin observation towers on the two-story pavilion. Refreshments could be bought on the first floor and enjoyed in the large open seating area on the second story. (Courtesy Frank A. Almquist Collection.)

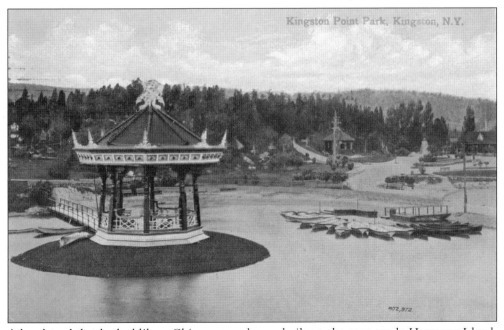

A bandstand that looked like a Chinese pagoda was built on the man-made Harmony Island. Music from the bandstand floated over the waters from the afternoon and evening concerts featured daily. (Courtesy Friends of Historic Kingston Archives, Herman Boyle Collection.)

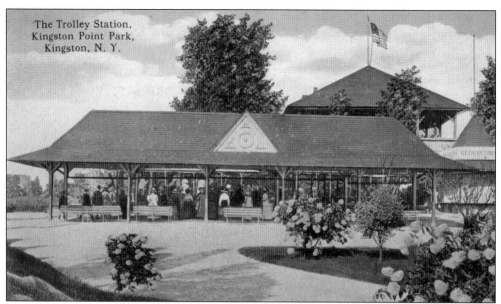

The trolley station at Kingston Point Park was surrounded with landscaping as lush as in the remainder of the park. A reproduction of the station was erected by the Kingston Rotary Club and provides picnic tables under the roof. In 1990, the Kingston Rotary Club began a three-year effort to restore the park, which was overgrown with brush. The amusement park closed in 1931, but the Hudson River Day Line continued to make landings there until September 1948. The Rotary Club holds annual clean-ups at the park. (Courtesy Frank A. Almquist Collection.)

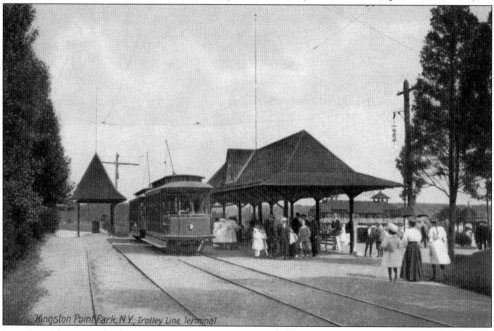

Local residents packed trolleys from Coykendall's Colonial Trolley Line and rode down to Kingston Point Park on summer evenings to enjoy the park's many amusements and to catch a cool breeze from the Hudson River. The trolley trip cost 5¢. (Courtesy Dr. William B. Rhoads Collection.)

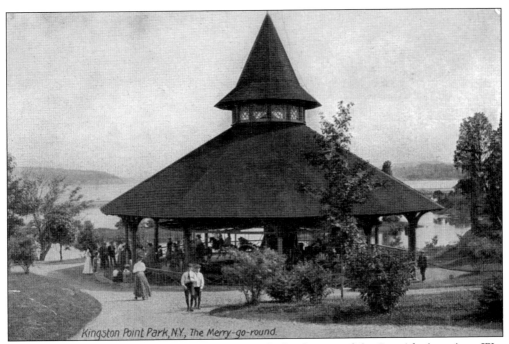

The merry-go-round had 30 horses, two named after heroes of the Spanish-American War of 1898. After the park closed, it was bought by a Kingston resident and stored in a barn near Abeel Street, but it eventually disappeared. Its whereabouts became the subject of some mystery. (Courtesy Friends of Historic Kingston Archives, Herman Boyle Collection.)

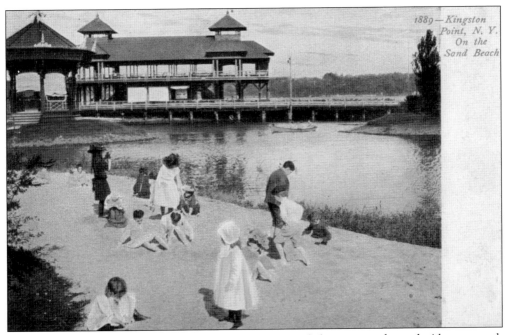

A sandy beach for bathing was created and also a man-made lagoon on whose placid waters park visitors could paddle rented canoes or rowboats. (Courtesy Frank A. Almquist Collection.)

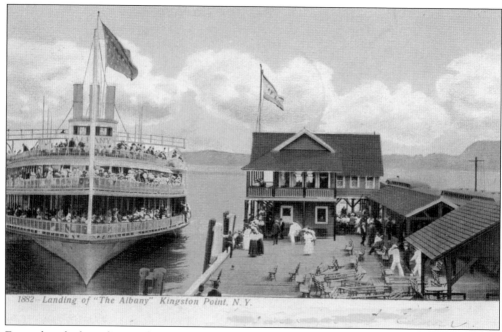

1882—Landing of "The Albany" Kingston Point, N.Y.

Every day, the large liners of the Hudson River Day Line disgorged hordes of people from up and down the Hudson Valley at Kingston Point Park. A crowd of local citizens routinely gathered to watch the liners dock. Young boys who came to be called "penny divers" would scramble for coins thrown into the water by people from the decks. The last day liner, the *Robert Fulton*, docked at Kingston Point on September 13, 1948. (Courtesy Frank A. Almquist Collection.)

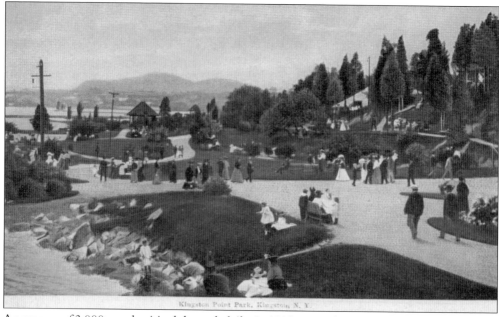

Kingston Point Park, Kingston, N.Y.

An average of 3,000 people visited the park daily. In 1903, more than one million people came by train, with the attendance record peaking on the Fourth of July. Approximately 28,000 people visited in that one day alone. (Courtesy Frank A. Almquist Collection.)

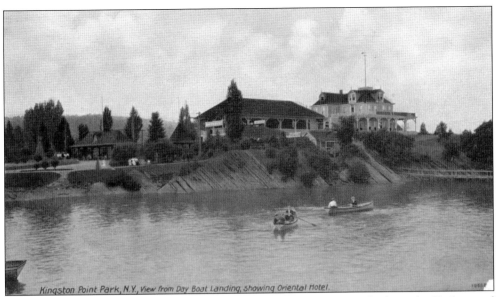

Kingston Point Park, N.Y., View from Day Boat Landing, showing Oriental Hotel.

Just outside Kingston Point Park, the Oriental Hotel sat on a bluff overlooking the Hudson and offered a commanding view of the river. Owned by the Hoffman Brewery, the hotel also offered alcoholic drinks, which were forbidden within the park, earning it the moniker the "Sunday School Park." In 1922, the hotel was consumed by fire as though signaling the beginning of the end of Kingston Point Park. (Courtesy Friends of Historic Kingston Archives, Herman Boyle Collection.)

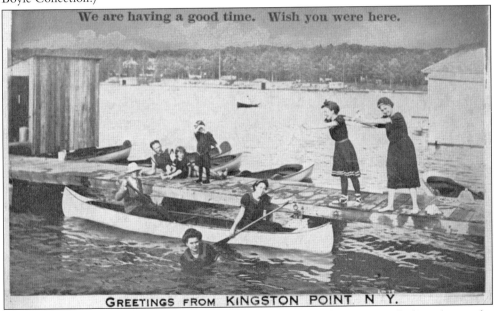

We are having a good time. Wish you were here.

GREETINGS FROM KINGSTON POINT, N.Y.

The good times began to fade in the 1920s, when park visitation saw a decline due to the automobile and a change in people's travel patterns. The amusement park closed in 1931. In 1965, the City of Kingston bought the property. Today, mainly due to the arduous efforts of the Kingston Rotary Club, people can walk the winding paths, picnic, fish, and watch boats go by on the Hudson River once again. Visitors can even ride a trolley from the Trolley Museum in Rondout to Kingston Point Park again. (Courtesy Edwin M. and Ruth Ford Collection.)

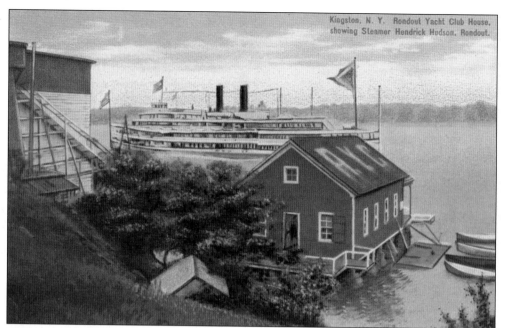

The Rondout Yacht Club was just north of Kingston Point Park. Later, it became known as the I.J.B. Club, the initials standing for Irish, Jews, and Binnewaters (a local term for Protestants). It was mainly a social club for which no pedigree was required to belong. (Courtesy Friends of Historic Kingston Archives, Herman Boyle Collection.)

As the game of golf gained in popularity, men and women of stature in Kingston wanted to have their own place to play. The Twaalfskill Golf Club was organized in 1902 using land off West O'Reilly Street leased from Samuel D. Coykendall and the Montrepose Cemetery Association. The original 1905 clubhouse shown above burned in 1925 and was replaced in 1926 with a similarly styled building. The word *Twaalfskill* derives from Dutch and means "striped bass." A creek that runs parallel to nearby Wilbur Avenue bears the same name. (Courtesy Edwin M. and Ruth Ford Collection.)

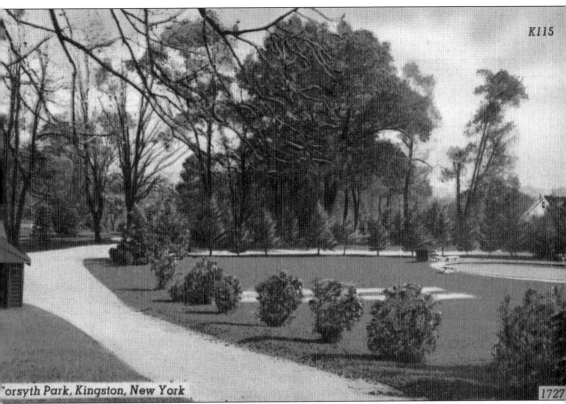

Forsyth Park, Kingston, New York 1727

In 1915, the city received its first donation of parkland when 18.55 acres on Lucas Avenue were donated by the family of former Ulster County judge James C. Forsyth. Daughter Mary Isabella Forsyth, an author and noted local philanthropist, cosigned the deed. In 1936, a WPA project added the wading pool, pavilion, tennis courts, ball field, and a house for a bear that wandered onto the grounds, the first of several legendary bears to be sheltered there. It was the start of the Forsyth Nature Center, which now features 24 animal exhibits and gardens. (Courtesy Frank A. Almquist Collection.)

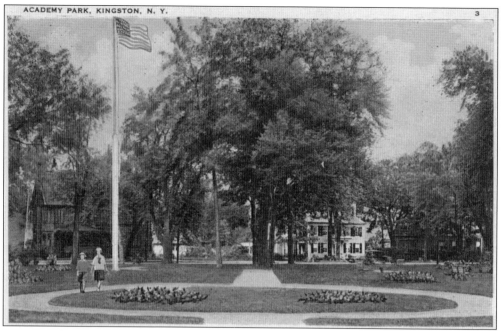

The former site of Kingston Academy, a triangular piece of land formed by Maiden Lane and Clinton and Albany Avenues, was deeded by the school's trustees to the City of Kingston for $1 on July 18, 1918. The school building was demolished in 1916 after Kingston High School on Broadway opened. The flagpole was purchased with pennies saved by local schoolchildren. (Courtesy Frank A. Almquist Collection.)

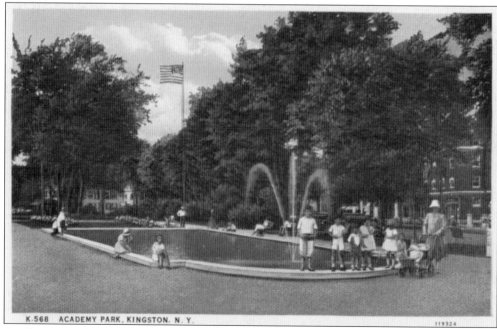

A reflecting pool, costing nearly $2,000, was donated to the park in 1924 by Mrs. Charles Cantine. It was later converted to a wading pool for children. (Courtesy Frank A. Almquist Collection.)

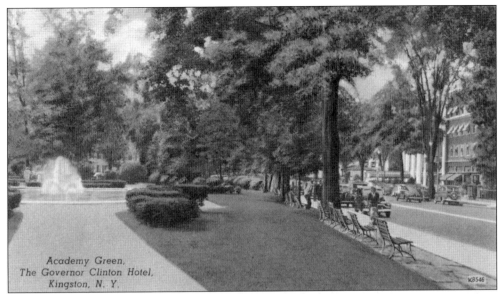

In 1982, the wading pool met the same fate as all the others in the city park system and was filled in and covered with grass. At the park's east end, a turn-of-the-century wrought iron fountain that had graced the campus of St. Ursula's Academy on Grove Street was installed. The fountain was donated by the Children's Home of Kingston, which had purchased the Grove Street campus. (Courtesy Frank A. Almquist Collection.)

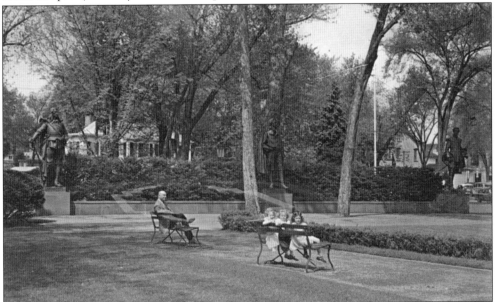

In 1950, statues of three figures notable in New York State and Kingston history—Henry Hudson, Peter Stuyvesant, and George Clinton—were installed at the Academy Green. The statues, which once stood in front of the Exchange Court in New York City, had been rescued from a Brooklyn scrap yard by a local resident, Emily Chadbourne. The Academy Green is thought to be the site where Peter Stuyvesant signed a treaty with the Esopus Indians on July 15, 1660, ending the first of two wars between Kingston's early European settlers and the Esopus Indians living in the area. (Courtesy Friends of Historic Kingston Archives, Herman Boyle Collection.)

The City of Kingston obtained the sanitarium property in 1944 under the provisions of the will of Dr. Sahler's wife, Charlotte. The sanitarium building was demolished and a park created with picnic benches, playground equipment, and a softball field. Sahler Park, in turn, was deeded by the city to the Kingston School District on July 5, 1951, for $1 for the purpose of erecting the George Washington School on the site. (Courtesy Friends of Historic Kingston Archives, Herman Boyle Collection.)

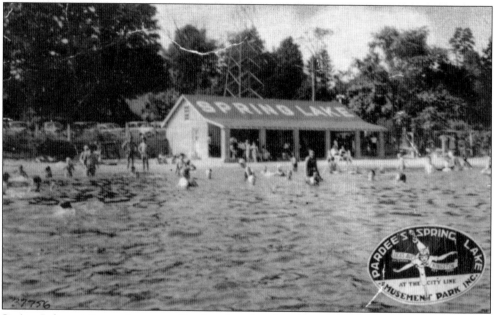

Spring Lake, on Lucas Avenue, offered swimming, boating, and an indoor roller rink where skates were available for rental. Skaters whirled around the circular rink to piped-in organ music, and periodically, a voice came over the loudspeaker to announce "Couples only on the floor." A mobile home development occupies the site today. (Courtesy Friends of Historic Kingston Archives, Herman Boyle Collection.)

11. Augusta St. House
:ident's Day Blizzard. Series by JAS 2003

Snow drapes the slate roof of the c. 1894 Coykendall coach house at 12 Augusta Street in this 2003 photograph by J. Schoonmaker. The redbrick and half-timbered building quartered the coaches and horses for Samuel Coykendall, the business mogul whose mansion was on neighboring West Chestnut Street. In the 1950s, it was converted to a 250-seat theater for an amateur group of thespians who dubbed themselves the Coach House Players. For more than 60 seasons, the Coach House Players have mounted more than 200 productions. Props are kept in the former hayloft, and the horses' sleeping quarters house thousands of costumes. (Courtesy Frank A. Almquist Collection.)

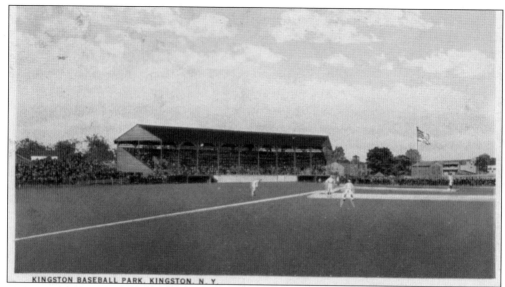

KINGSTON BASEBALL PARK, KINGSTON, N. Y.

The Kingston Fair Grounds, now Dietz Stadium, was purchased by the City of Kingston in August 1921 and transformed into a facility meant mainly for baseball. It had a covered grandstand that could hold 2,500 spectators and was nicknamed the "Polo Grounds." The Kingston Colonials played at the fairgrounds from the 1920s through the late 1940s. A highlight in its history was October 16, 1926, when Babe Ruth played first base for the Colonials at the field. Football was also played from 1926 to 1941 at the fairgrounds by Kingston's famous semipro team, the Yellow Jackets. (Courtesy Frank A. Almquist Collection.)

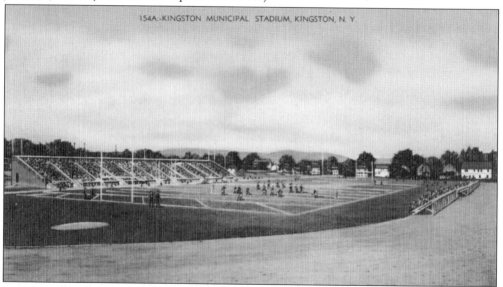

154A.-KINGSTON MUNICIPAL STADIUM, KINGSTON, N. Y.

In 1937, the city bought the fairgrounds for $10,000, renamed it the Kingston Municipal Stadium, and embarked on a two-year improvement project, installing a new baseball/football field, running track, dressing rooms, restrooms, and grandstand seating for 2,100 people. To prepare the field for drains, 4,000 tons of rock had to be removed. On June 21, 1941, lights were turned on for the first time. On Memorial Day, 1954, the facility was renamed Dietz Stadium in memory of S.Sgt. Robert H. Dietz, who was posthumously awarded the Congressional Medal of Honor for his heroic action in 1945 in Kirchain, Germany. (Courtesy Frank A. Almquist Collection.)

122

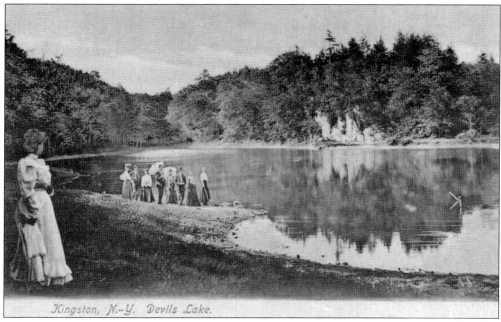

Driving out First Avenue towards East Kingston, Devil's Lake straddles the city line. During the 1800s, Devil's Lake was a popular place for boating, swimming, fishing, and picnicking. (Courtesy Friends of Historic Kingston Archives, Herman Boyle Collection.)

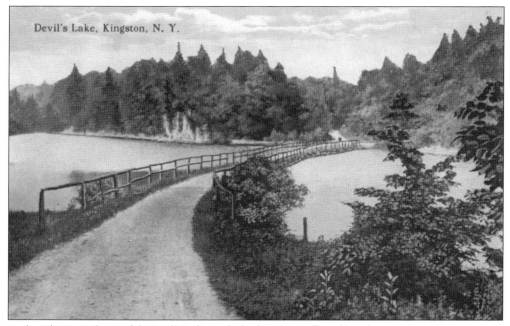

Today, the once-beautiful Devil's Lake is choked with weeds and barely recognizable. A glimpse of the former lake can be caught to the right while driving east over the George Clinton (Kingston–Rhinecliff) Bridge. (Courtesy Margaret O'Reilly Paulson Collection.)

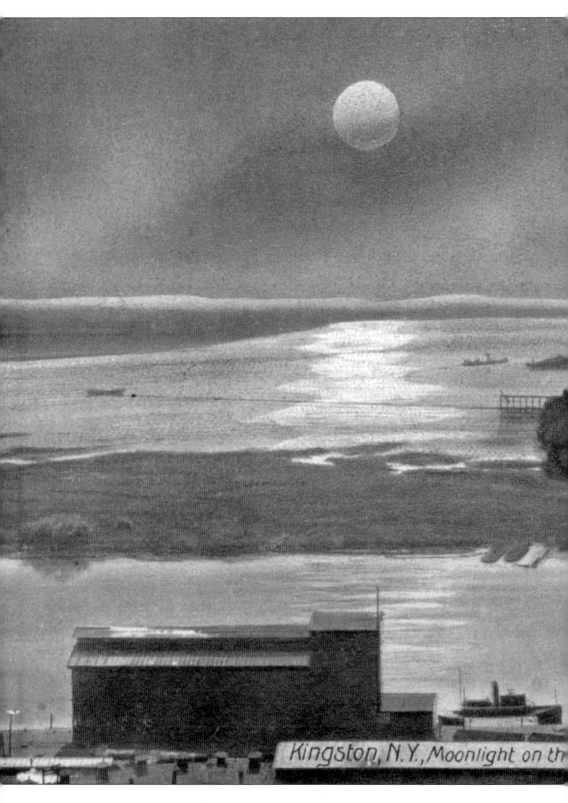

Kingston, N.Y., Moonlight on th

124

This moonlit view of the Hudson River and Rondout Creek was most likely photographed from Hasbrouck Park, whose heights afford a panoramic view, making it a favorite place for artists to set up their easels to paint. Before heavy industrialization occurred along the Rondout Creek, noted Kingston landscape artist Joseph Tubby (1821–1896) captured several Hudson River vistas on canvas. The Hasbrouck Park location is included on the Hudson River Valley National Heritage Area's Hudson River School Art Trail. (Courtesy Frank A. Almquist Collection.)

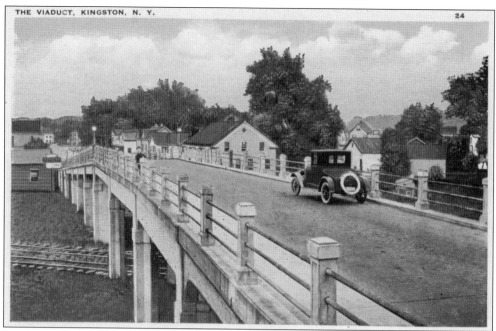

Leaving Kingston heading west on Route 28 towards Woodstock, the Washington Avenue Viaduct allowed cars to pass over the railroad tracks. In the late 1960s, the viaduct was demolished and the road leveled. Today, that stretch of Washington Avenue is highly commercialized. (Courtesy Frank A. Almquist Collection.)

Water from the Mink Hollow Stream in the Catskill Mountains is piped into Cooper's Lake Reservoir in Lake Hill, New York, the source of Kingston's water supply. The reservoir has a holding capacity of 1.2 billion gallons. The Catskill Mountains form a scenic background for the city of Kingston. (Courtesy Margaret O'Reilly Paulson Collection.)

BIBLIOGRAPHY

DeWitt, William C. *People's History of Kingston, Rondout and Vicinity.* New Haven, CT: Tuttle, Morehouse, and Taylor Co., 1943.

Ford, Edwin M. *Street Whys: Anecdotes and Lore about the Streets of Kingston, New York.* Round Top, NY: Ford Printing, 2010.

Ford, Edwin M. with Friends of Historic Kingston. *Kingston.* Charleston, SC: Arcadia Publishing, 2004.

Hickey, Andrew S. *The Story of Kingston.* New York, NY: Stratford House, 1952.

Hutton, George V. *The Great Hudson River Brick Industry.* Fleischmanns, NY: Purple Mountain Press, 2003.

Moffett, Glendon L. *The Old Skillypot and Other Ferryboats of Rondout, Kingston and Rhinecliff.* Fleischmanns, NY: Purple Mountain Press, 1997.

———. *Uptown-Downtown, Horsecars-Trolley Cars, Urban Transportation in Kingston, New York, 1866–1930.* Fleischmanns, NY: Purple Mountain Press, 1997.

Rhoads, William B. *Kingston New York: The Architectural Guide.* Hensonville, NY: Black Dome Press, 2002.

———. *Ulster County New York: The Architectural History & Guide.* Delmar, NY: Black Dome Press, 2011.

Schoonmaker, Marius. *The History of Kingston. New York.* New York, NY: Burr Printing House, 1888. Reprinted by Higginson Book Company, Salem, MA: 1997.

Steuding, Bob. *Rondout, A Hudson River Port.* Fleischmanns, NY: Purple Mountain Press, 1995.

Woods, Ron. *Kingston, A Century of Play and the Major Players.* Saugerties, NY: Hope Farm Press, 2000.

———. *Kingston's Magnificent City Parks.* Self-published. Kingston, 1992.

DISCOVER THOUSANDS OF LOCAL HISTORY BOOKS FEATURING MILLIONS OF VINTAGE IMAGES

Arcadia Publishing, the leading local history publisher in the United States, is committed to making history accessible and meaningful through publishing books that celebrate and preserve the heritage of America's people and places.

Find more books like this at
www.arcadiapublishing.com

Search for your hometown history, your old stomping grounds, and even your favorite sports team.